NORTHUMBERLAND
Hills & Valleys

Stan Beckensall

AMBERLEY

First published 2012

Amberley Publishing
The Hill, Stroud
Gloucestershire, GL5 4EP

www.amberleybooks.com

British Library Cataloguing in Publication Data.
A catalogue record for this book is available from the British Library.

ISBN 978 1 4456 0358 2

Typeset in 10pt on 12pt Sabon.
Typesetting and Origination by Amberley Publishing.
Printed in the UK.

Contents

Acknowledgements

I am grateful to Marc Johnstone whose professional maps are included, to the University of Newcastle for one illustration and to Tony Iley of 'The Hexham Courant' for another. The rest are mine.

I am grateful to the staff of Amberley Publishing for the final book.

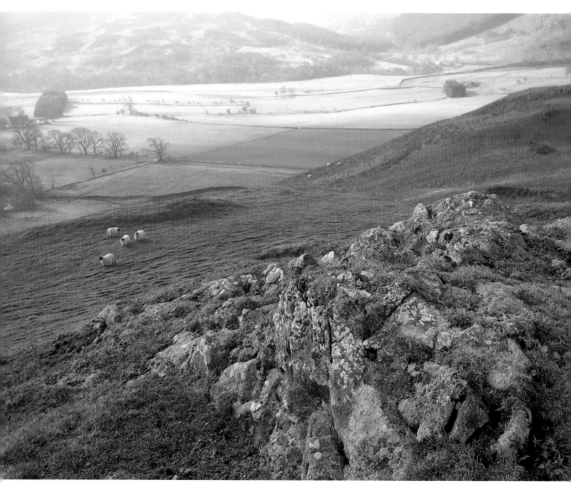

The Vale of the River Coquet below a prehistoric enclosure at Alwinton, called Castle Hill, the volcanic outcrop of rock at its centre. Sheep are at the line of a rampart.

Introduction

There was a time when ignorance of the extent of Northumberland's fascinating landscapes was the result of a misconception that the county was devoted almost exclusively to industry. Industry continues to play its part in wealth creation, but there are great areas of attractive countryside and settlements that offer a wealth of visual experiences that have brought in people who want to live there or to enjoy holidays in a landscape that has an extensive coastline, hills, and valleys established millions of years ago and modified by human settlement. Northumberland's history is rich and much of it is still to be seen. Because of its position on the Scottish border, part of its early history has been turbulent when other parts of the country were enjoying more peace, and this has left its mark on people's lives and literature. More recently, its great mineral wealth put it at the forefront of the industrial expansion that made Britain 'The Workshop of the World' and produced inventors and entrepreneurs that were second to none. All this depended on what was there already – the land that supported its agriculture, and the minerals that lay within it.

Northumberland has a varied landscape; the county stretches along the coastal plain for many miles along the North Sea and includes the volcanic Cheviot Hills, the flat Milfield Plain, extensive scarpland and a spread of sandstone, coal and limestone with their great industrial potential. Its scenery is based on solid geology, deposition and on the changes that people have made in farming, industry and building. The apparently more level surfaces can be deceptive, as there are many small ridges and water courses that add subtle variety.

This photographic survey will exclude the coastal area, as I have recently covered much of this in other works such as *Coastal Castles of Northumberland* (2010) and, in concentrating on hills and valleys, the account has to be highly selective in showing which places best display the variety of scenery and the impact of people on the landscape.

Each section begins with a brief, general picture, and then focuses in detail on representative areas of the county.

The Cheviot Hills/Cheviots are the highest land, the Cheviot itself rising to 815 m, for example, and Windy Gyle to 619 m. There are no mountains, although many agricultural reports of the nineteenth century refer to some high ground as such. The Cheviots were volcanic for millions of years from around 400 million years ago, when ash exploded from deep down and where lava flowed. At its centre is granite, and around the massif are other fire-formed rocks that have been changed in their composition by heat and pressure, giving a variety of forms. Ice was later to bury the whole country and these

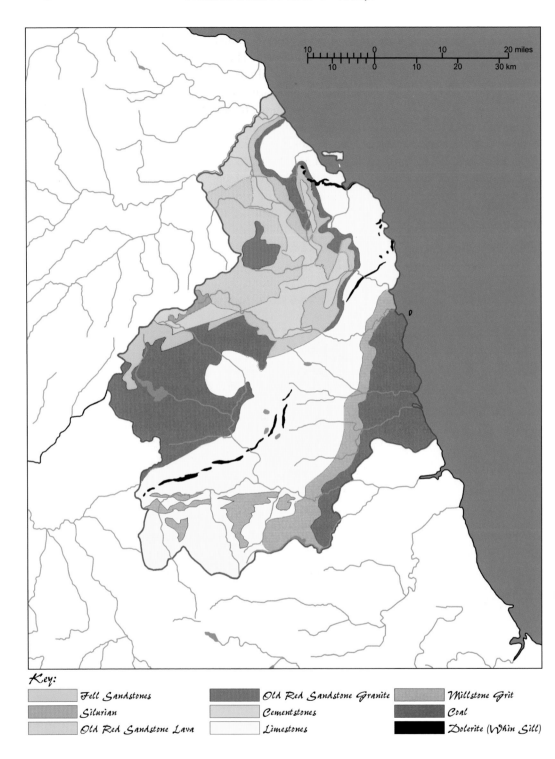

Key:

	Fell Sandstones		Old Red Sandstone Granite		Millstone Grit
	Silurian		Cementstones		Coal
	Old Red Sandstone Lava		Limestones		Dolerite (Whin Sill)

Map of the whole county. (Marc Johnstone)

volcanic rocks were ground down to a more rounded shape, although there are still some volcanic plugs and crags rearing out of it. The Cheviots are a distinct cluster of hills separated by deep valleys, with a thin soil layer today suitable for limited arable agriculture, though it has been used by early farmers as a major area of ploughland and pasture, still to be seen fossilised because there are not many people who use the land in this way, leaving it with a small population and the addition of planted coniferous forest. Now, although it still supports an important farming community, its wide open landscapes and heights also make it a popular place to visit.

Another major source of rock, and therefore a shaper of landscapes, was the laying down of water deposits of sand, mud, lime and coal, into which metals such as galena (lead), zinc and iron were injected – the basis of many important industries that changed the face of the land.

Prominent among these sedimentary rocks in the north of the county are the sandstone scarplands and their dipslopes.

These scarps form a distinctive ridge, but other sedimentary rocks form less pronounced but wider areas of rough moorland seen particularly in the west in places like the Otterburn ranges and the Kielder area.

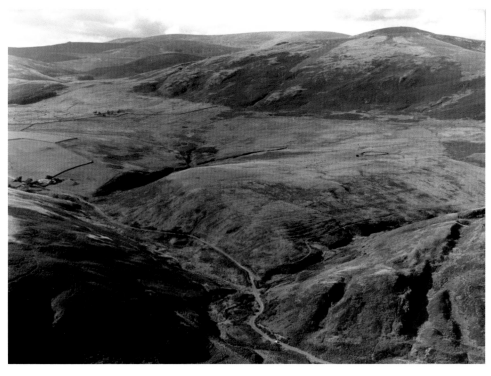

The Breamish Valley within the Cheviot Hills, from the air: the area centre left is the farm, Greensidehill, past which a stream flows to join the main river, the Breamish, which makes its way eastward in the Ingram Valley. Bottom right is massive andesite volcanic rock on a sheer fault line. To the left is Hartside Hill. Higher land rises from the fairly level ground to rounded hills with some crags breaking out of them. Hills rise upon hills, reaching their greatest height at Hedgehope and The Cheviot.

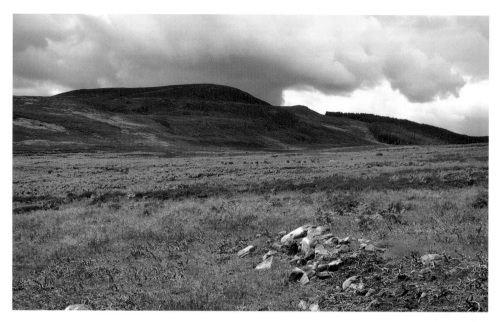

A Fell Sandstone scarp at the Simonside Hills, south of Rothbury: Fell Sandstone forms a wall of rock that circles the Cheviot Hills, but distant from it. We look at the scarp from a lower ridge at Lordenshaw.

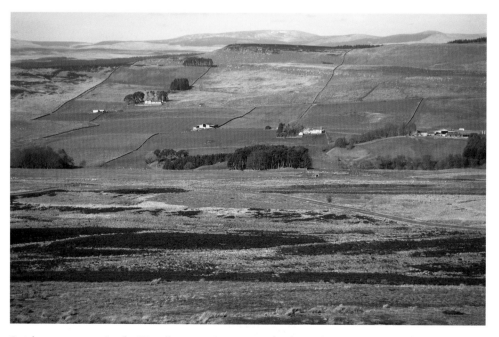

Sandstone country in the Woodburn-Ray area: Much of Northumberland outside the Cheviot Hills and Fell Sandstone scarpland is formed of deposits of sand, shale and coal. This picture is taken between Corsenside and Kirkwhelpington, with the Cheviot Hills on the horizon to the north. Streams have carved this valley, leaving sandstone ridges on either side. It is close to a major Roman road, now the A68, to the left.

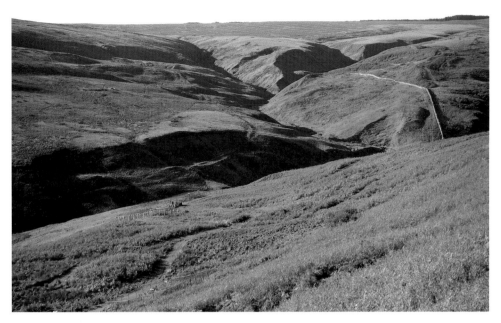

Pennines: the south-west of the county. The road from Hexham to Alston, one of the most attractive routes in England, passes over the High Pennines, which are formed of limestone. In this view close to that road, the different levels of rock are clear, bedded horizontally, and deeply cut by streams.

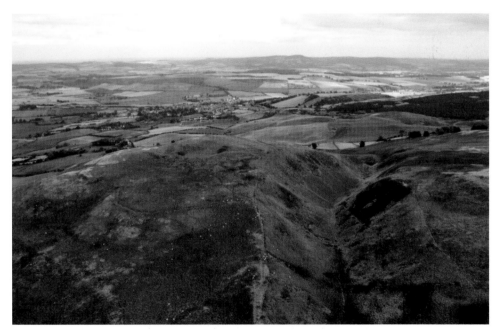

The Milfield Plain from Humbleton Hill. The Milfield Plain is the valley of the River Till, a large stretch of sand and gravel that lies between the Cheviot Hills and the Fell Sandstone scarp, seen here on the horizon. Below Humbleton Hill, with its deep ravine (right) and prehistoric settlement (left) is the large village of Wooler, and beyond that is Coldmartin Hill and Weetwood Moor.

Further south, the limestone areas of the Pennines begin to dominate the landscape, with their many abandoned lead workings and smelting sites.

The earth is constantly moving, albeit very slowly in human time, and some features result from upheavals and faults.

There is a secondary intrusion of volcanic material in ridges across the county, forming dykes of dolerite/basalt/whinstone; we see how this, locally, has changed the scenery and provided a very hard rock for road-building.

All these layered rocks dip away from the Cheviot; their composition, hardness and softness is what forms the land that we see today. Add to that the superficial deposits left by glaciers and rivers, and their use by people, and we have even more variety of scenery.

A particularly distinctive area of glaciation is to the north of the county, the Milfield Plain.

From these brief introductory glimpses, the spotlight now falls on more detailed pictures, beginning in the north-west with the Cheviot Hills.

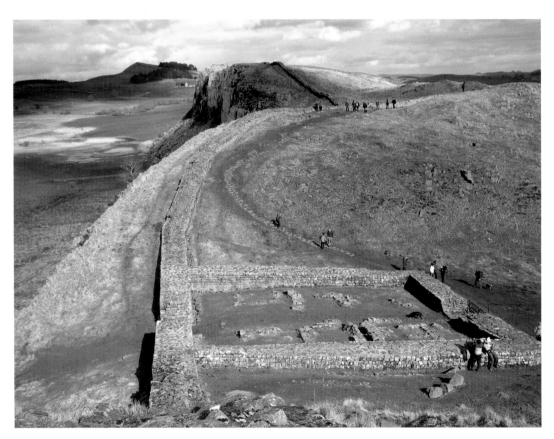

The Roman Wall and whinstone ridge following sedimentary rocks along a fault line: the central section of the Roman Wall is dominated by vertical columns of basalt/dolerite which follow a switch-back course of varied scenery that is particularly attractive for walkers. The Emperor Hadrian found this feature a distinctive high point for his remarkable frontier wall that separated the Romans from the 'barbarians' to the north. This picture is taken west of Crag Lough.

The Cheviot Hills

The core of the Cheviot Hills is a vast plug of granite, around which other fire-formed rocks such as andesite and porphyrite cluster. Exposure in a few places, such as steep valleys, reveals them. They are ice-scoured, but unlike the lowlands, the melting ice did not leave large amounts of fertile boulder clay, although some ice deposits are still visible. Valleys particularly show where the glaciers ran and melted, largely in the smooth, U-shaped profiles of their slopes. Into those valleys ran streams and springs, providing the major source of Northumberland's rivers, which flow roughly from west to east to the North Sea, although the River Breamish bucks the trend by turning north, then breaking through a sandstone scarp to the east, from where it flows north across the Milfield Plain to join the Tweed, and on to the sea.

The rivers Tyne, Wansbeck, Coquet, Aln, Breamish/Till and Tweed widen as they near the sea, and their banks have deposits of alluvium, which, combined with gravel terraces, provide rich local soils.

The Cheviots are highly visible from many places in Northumberland, with the plateau-like sloping centre, the Cheviot itself, particularly clear among the other hills, as we see from many directions.

Volcanic rock is seen in screes and in boulders on the surface, as well as in commercial exploitation. There is an abundance of evidence of the importance of these hills to early people who lived among them, farmed, buried their dead there, and hunted.

Two-thirds of the Cheviot Hills are in Northumberland, including the central granite core which forms a high plateau from which all the other hills descend in size. This core determines the pattern of streams, radiating like spokes to feed rivers. Many of the streams follow fault lines where earth movements have taken place, many in straight lines, cutting deep, narrow V-shaped clefts in the rock, but in the core the eroded valleys are wide and shallow – like part of the River Breamish valley and that above Linhope.

As we move away from the central core of the Cheviots we see around it an area 200 m lower where the vegetation differs.

The inner plateau is rich in calcium, favoured by heather, but lower down andesite takes over (silica of alumina, lime and soda), allowing grass and bracken to dominate. There are some pockets of heather away from the core which thrive on pyroclastic beds and rhyolite lavas (very fine-grained rocks), once fluid volcanic rocks.

Volcanic action which formed the hills took the form of huge explosions from vents or of molten lava flows. Andesite was mainly formed by lava, and granite was injected – or exploded – into the centre of it. These explosions spewed out pyroclasts ('pyro' is Greek for fire-formed and the rock was made of fragments broken up by eruption).

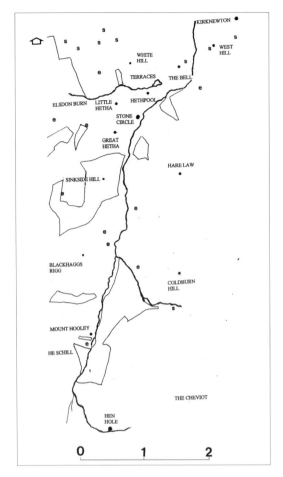

Map of the Cheviot Hills.
(Marc Johnstone)

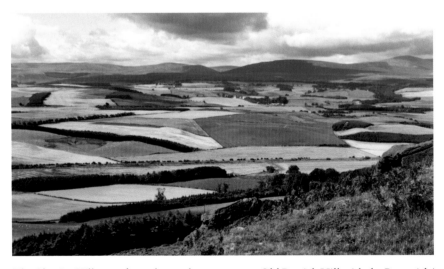

The Cheviot Hills seen from the sandstone scarp at Old Bewick Hill with the Breamish/
Till Valley in between. The valley slightly undulates with deposits of Boulder Clay left
behind by retreating ice, which provides fertile soil.

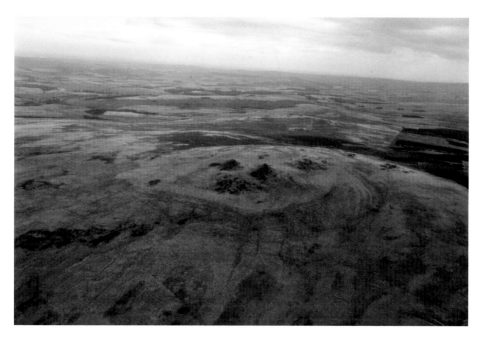

The core from the air: 'plugs' of uneroded igneous rock remain in some places, although the general profile of the hills is smooth and rounded.

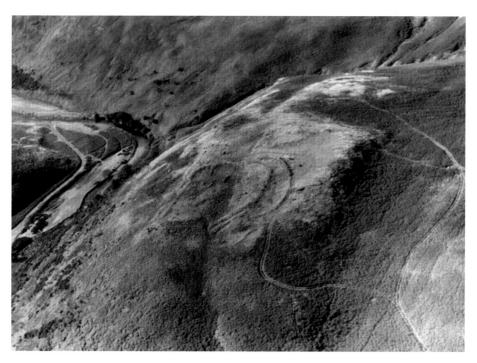

The River Breamish valley: andesite outcrops in the Ingram Valley slope steeply to the winding, deep cut of the river. In the centre of the picture a prehistoric enclosure shows how the land was settled over 2,000 years ago. The thin soils were ploughed and grain grew there, but there was always great reliance on herds of animals.

From Yeavering to the Cheviot: the large tribal hillfort on Yeavering Bell ('hill of the wild goats') centres on many ancient field systems and settlements, before the people moved to lower ground, mainly as a result of deteriorating climate and decline in soil fertility. The heather is in bloom. Today a herd of wild goats lives here.

A pyroclast at Brough Law This is one of a line of colourful boulders apparently placed across the southern approach to the hillfort of Brough Law.

Pyroclasts formed beds of varying grain size, and on the surface are rough; they can be seen on the steep slopes of the Ingram Valley and at Linhope. When the granite was forced through the andesite, the intense heat changed (metamorphosed) anything that came into contact with it. The crags, or 'tors', of Housey Crags and Middleton Crags were formed in this way. There are also granite tors such as Great and Little Standrop, Cunyan Crags and the south-east shoulder of Dunmoor Hill.

It is not always possible to identify types of rock in the field: geologists classify the different rocks by examining slices of them under a microscope, which reveals all the minerals in their make-up.

Another feature of the hills and beyond was the intrusion of molten rock in lines called dykes, which can crop up anywhere. There are some dykes running across Yeavering Bell, quarried to help make the huge ramparts there. The dykes tend to run in a NNE–SSW direction.

Outside the Cheviot hill region such dykes can be seen prominently at sites like Hadrian's Wall and Bamburgh. Another famous intrusion is a 'laccolith' at Harden Quarry, Biddlestone, probably a late infusion of granite.

Within the hills are faults; some are very large and others, like the Breamish fault, are smaller, where granite is thrown up against the andesite. The College Valley lies on a fault that makes it run straight and deep. This is one of many which have now been traced with the help of aerial surveys.

Another factor in shaping landscape is glaciation, when the region was covered with great ice sheets which moved outwards from the Cheviot dome. Crags like those at

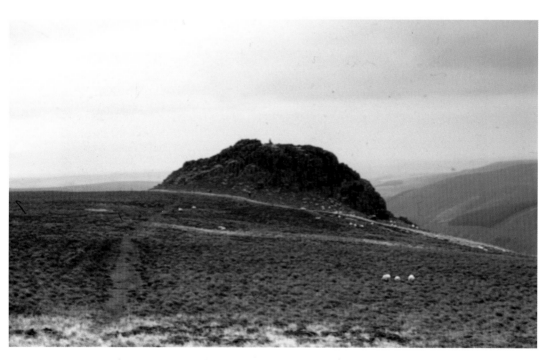

Housey Crags: the tor rises significantly out of surrounding land which has some prehistoric settlement around it.

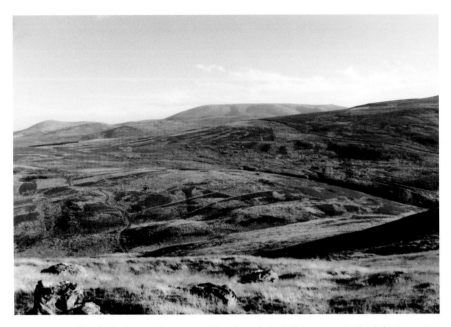

Yeavering Bell, which four dykes cross. The site of the hillfort, 'capital' of the Votadini tribe over 2,000 years ago, is dominant in its views. Its long saddle is surrounded by a wall of stones that make its interior the largest of its kind in Northumberland, containing at least 130 depressions of hut circles. From the hill we see a lower slope where there are other settlements of the same period, and in the distance is The Cheviot.

Harden laccolith: the ridge of the laccolith is on the horizon, with a quarried exposure to the right above the trees.

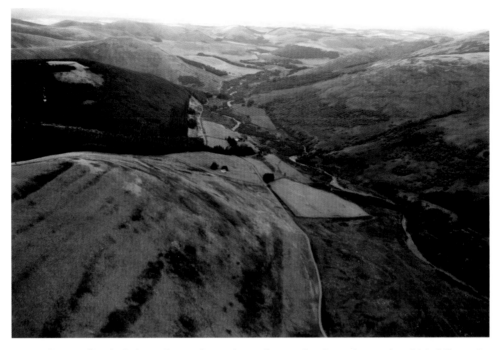

The College Valley fault from the air shows the College Valley from the south, which follows the line of a major fault. To the left, planted forest covers Sinkside Hill, beyond which is the large hillfort of Great Hetha. Before the building of the fort, perhaps 2,000 years earlier, the valley was the site of a stone circle, part of which remains on its flat floor. Scattered farming communities would have built this as a focus for the people to meet.

Langley and Housey are moulded north–south in the direction of the ice flow. When the ice melted this had an effect on the landscape and could cut through many metres of solid rock.

To the south and east the igneous rocks are overlain by Carboniferous rocks, and we enter a different geological series. To follow this general picture, I have chosen parts of the Cheviot Hills where we can see good sections through them in more detail.

The Ingram Valley

The Ingram Valley is one of the finest entrances into the Cheviots and is a beautiful cross-section of what can be found generally. Its name means that it is a settlement in grassland (*Angerham* in 1242) supporting more pasture than arable land, though some of the valley floor is used as ploughland where the river has scooped out a wide valley and deposited richer soil than on the slopes on either side.

The River Breamish is the valley's waterway, fed by streams and springs from the hills. On either side of the narrow part of the Ingram valley volcanic scree slides down the hillsides. The floor has rig and furrow ploughing, now grass-covered, which was a medieval and later method of ploughing now seen because it was abandoned and

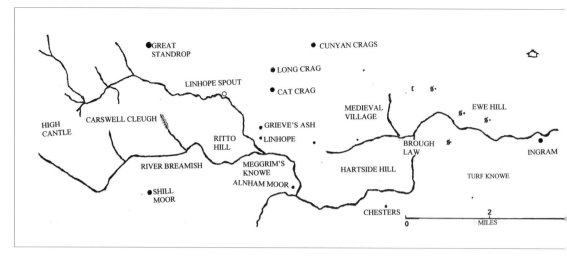

Detailed sketch map of the Breamish Valley. (SB)

left to grass over. Other parts of the valley floor have been recently ploughed. East of Ingram village is a floor of gravel, deposited by glaciers, forming a level area of pasture, extending to the Powburn gravel quarries.

The eastern part of the valley marks the end of the river's course in that direction, for it then turns north and at Old Bewick changes its name to the River Till, continues north between sandstone scarps, breaks through to the west at Weetwood Bridge, and flows north again across the Milfield Plain, joined by the Wooler Water and the River Glen, to reach the River Tweed.

Ingram is one of the best places to see how people from prehistoric times onwards used the land for their livelihood, settlement and defences. Not only are there strong visible traces of this, but also archaeology has contributed much to recovering some of what is buried there.

Subsidiary streams cut through the fire-formed rock to form narrow valleys with steep sides that made ideal defensive sites, in addition to the tops of hills. These sites have hundreds of years of farming around them, beginning with narrow prehistoric 'cord-rig', lynchets and terraces, which were also farmed in medieval times with the addition of the distinctive inverted S-shaped wide rig and furrow that characterises medieval agriculture, cutting through the terraces. The land has been divided with very long stone and earth-dump walls, sometimes focused on burial mounds, Emphasis on arable farming can be seen alongside other uses of fields for stock, and in areas that would have been used for hunting. We can distinguish pre-Roman and later settlements in this landscape, but also still see the burial cairns of the earlier Neolithic and Bronze Age folk. Earlier, small pieces of chipped flint and quartz reveal a Middle Stone Age presence.

This is one of the finest ancient landscapes in Europe; the pictures show how profuse the remains are and what their surroundings are, but it is from actual excavation that we learn much more about the life of these people. This area has been systematically photographed from above, like the rest of the hills, and has had an intensive ten-year recent ground survey and excavation programme that revealed dates, sequences, buildings, field systems, and burial customs from sites not disturbed before.

Detail
We shall now move into the valley from the east to see more of what is there.

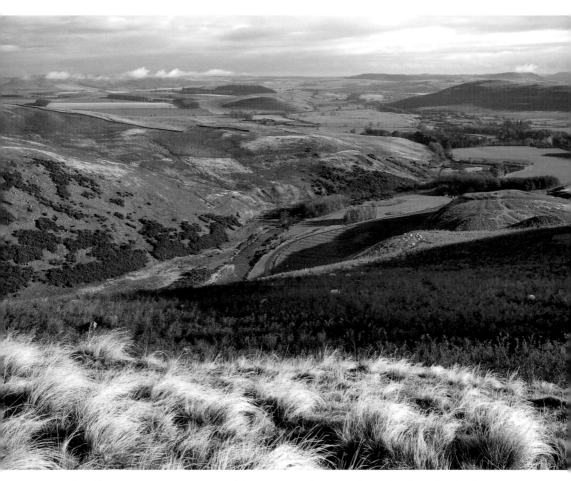

Breamish Valley, east: the eastern part of the Ingram valley, seen from the slope that leads up to Brough Law. To the right is wide rig and furrow ploughing, now grassed over, and covered with bracken. The River Breamish flows east, before turning north when it meets sandstone scarps that are seen on the horizon.

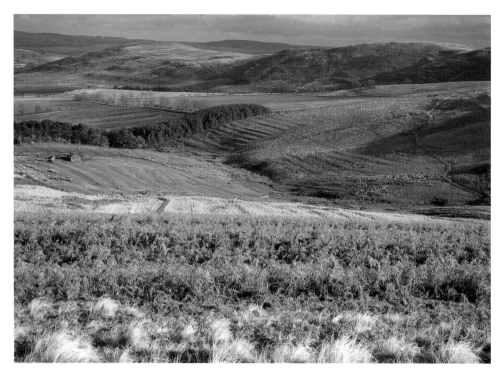

Ingram: terraces and rig and furrow, showing extensive cultivation. Beyond the eastern hills, on the horizon, is the Fell Sandstone scarp.

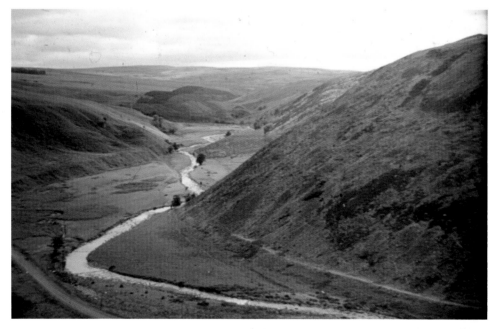

The valley floor is wide and uniform, flanked by hills, the river flowing through thick gravel deposits formed by ice and water. The valley follows a fault, cutting through steep slopes of andesite, where this volcanic rock is exposed.

One of the hills to the north of the river, Heddon Hill ('high') is a classic example of terracing, a series of stepped narrow fields formed by soil creep and walling for cereal growth. Across the terraces runs a different system of ploughing, in which wide rigs and furrows have an inverted S-shaped profile carrying them downhill.

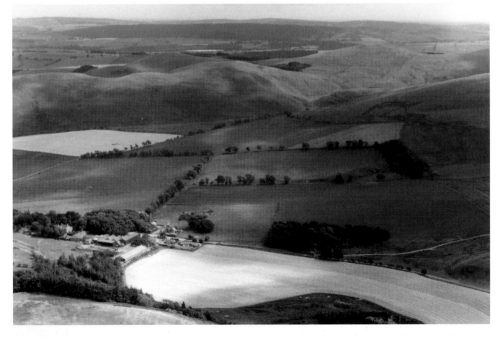

Ingram Farm lies to the left of the ploughed valley-bottom field, with the sandstone hills on the horizon once the smooth volcanic hills are cleared. The settlement has an ancient church further east and a community hall. A National Park Visitors' Centre, which houses some of the results of a ten-year programme of excavation as well as other information is about to be closed as part of government cuts. It has been a splendid guide to the archaeology of this important area.

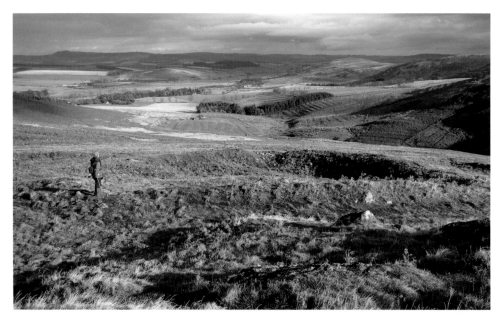

From a Roman-British settlement of an enclosure with sunken building sites there is a splendid view of the landscape to the north-east. With the field systems that surround it, this is one of the finest intact prehistoric and later areas in Britain. It is frozen in time after its abandonment, which adds to the exhilaration of walking across it.

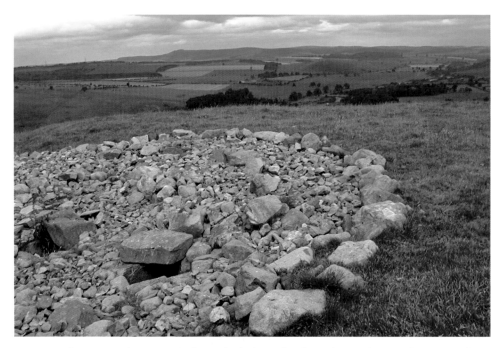

Two recently excavated cairns, which overlook the valley from the south at Turf Knowe, tell the story of how people regarded, and buried, their dead. A round cairn (pictured) of around 4,000 years ago has two cists in it (stone-lined boxes that have a capstone) where bodies and grave-goods were buried. The circular form is typical of the period. Until the excavation the cairn was unknown.

Perhaps more interestingly, on a slightly higher point, there is a 'tri-radial' cairn with arms of volcanic stone, some rounded, that are the focus of cremation burials in cists and pits with 'food vessels'. One of these cists was later disturbed, the contents, including a pot, moved to one side and an iron spear and cremation inserted hundreds of years later. Like the cairn below, it has extensive views over the valley and well beyond to the sea.

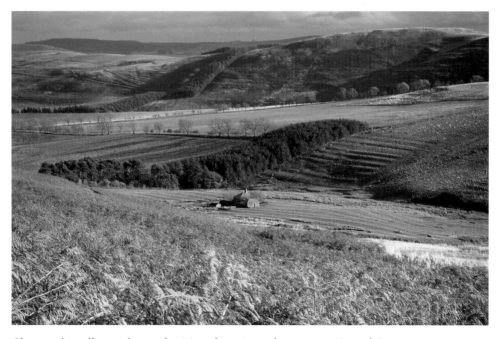

Close to the valley to the south, rising above it on the ascent to Brough Law, we can see more field systems that hug the ground, following the slope. The vegetation is considerably varied, as is the whole of the landscape seen from here towards the North Sea.

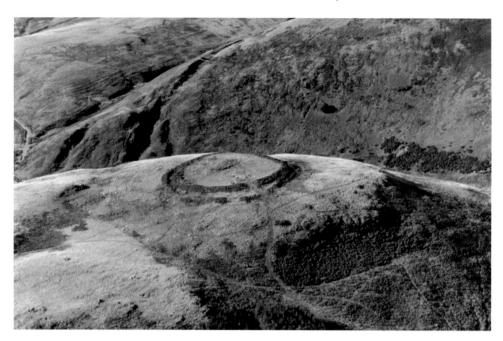

Towering above the valley is the pre-Roman hillfort/settlement of Brough Law ('fortified hill') built entirely of stones, some quarried and others rounded, enclosing a small area with a few hut circles that are faintly visible. The stone enclosure with its double walls at its entrance and an extra wall to control comings and goings from the south is one of the finest viewpoints in the hills.

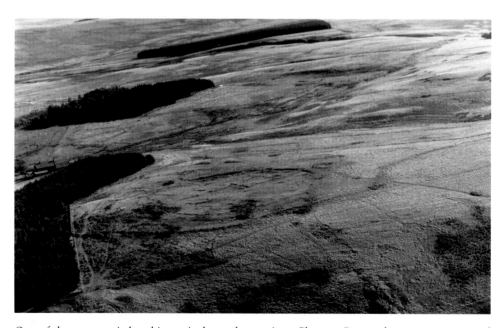

One of the most varied and intensively used parts is at Chesters Burn, where many types and ages of settlement are represented, best seen from the air. In addition to long 'stone-dump' walls, now covered with grass, there is group of circular huts inside a large, roughly circular enclosure. Elsewhere there are many field systems and traces of buildings.

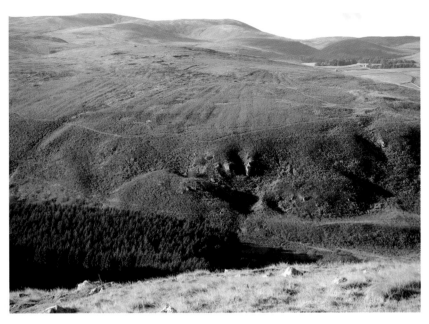

Visible from Brough Law is Hartside Law, with an abundance of ancient enclosures and fields. The road to the small modern settlement of Linhope passes these on the north, where we meet many more. Volcanic plugs to the north that form crags overlook a relatively flat area where a medieval village was once sited.

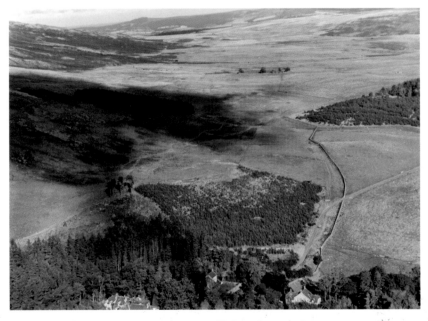

Greaves/Grieves Ash, a pre-Roman walled settlement, lies on our right as we approach Linhope, with a deep hollow way leading into it. There are two large circular enclosures and many round-house sites, linked to each other by walls, favouring the lower slopes of the hills, yet above the valley floor. A medieval village was situated further east on more level ground.

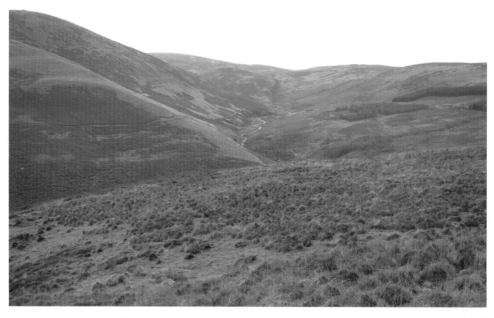

A view from Ritto Hill looking west: small valleys bring water into the Breamish, seen here near its source.

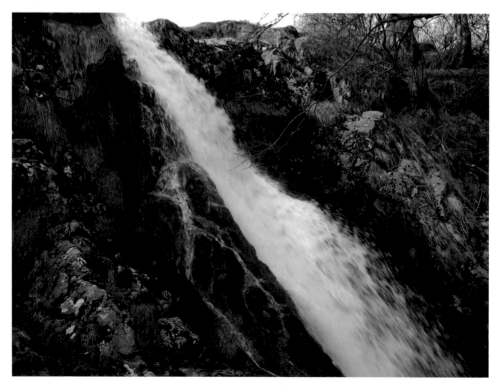

To the right (north) of Ritto Hill via prehistoric settlements on the slopes, a trackway leads to Linhope Spout, a small but hard-gushing waterfall that pours over a ledge to drop into a narrow valley.

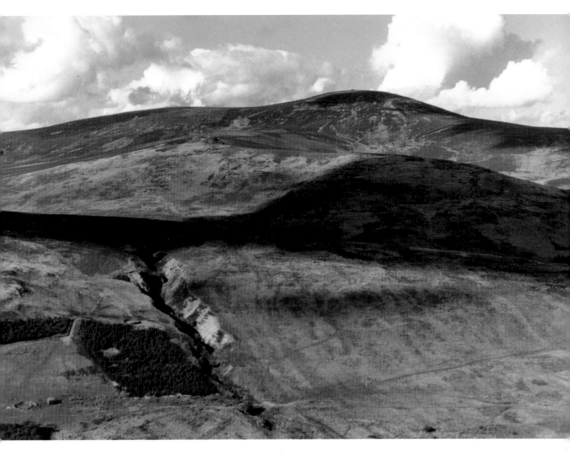

The River Breamish flows from the west (left). Carswell Cleugh ('rock-spring-ravine') is a tributary valley. Sheepfolds and woods to the left occupy the southern slope; to the right there is a wide downslope ploughed by wide rig and furrow, now grassed over. The hills to the north are Great Standrop and Hedgehope. The Linhope Burn valley is in cloud shadow. To the right is Ritto Hill.

Below its scattered stone slope (named 'The Glidders') the river is joined by a stream that flows in from the north-west, overlooked by a small prehistoric promontory fort.

It is obvious from OS maps how many old settlements there are in the hills, and this valley is a good example of their concentration. As we move to the north of the valley the hill slopes and tops reveal this, particularly when the bracken is dying off.

A walk along the valley from Ingram has opened up a world of hills rising above hills towards the heart of the massif. At the end of the road Ritto Hill rises like a giant cone above Linhope (the 'water valley').

The northern stream valley that runs in to join the waterfall pool is filled with lovely deciduous woodland, allowed to be self- generating because it serves no other purpose.

We shall now leave this fascinating landscape to picture the Cheviot Hills from other perspectives, though the same elements will recur.

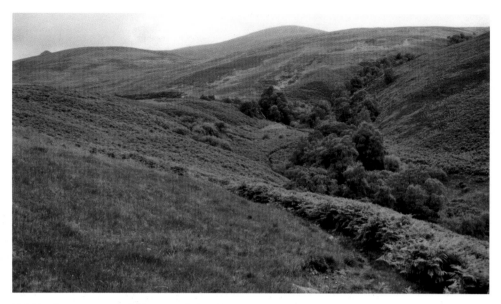

Within the same area, following the Linhope Burn upstream there is a part listed as an Area of Special Scientific Interest known as Standrop Rigg, where the slopes were again used for settlement, mostly overgrown with bracken, overlooked by volcanic plugs.

The College Valley

The focus shifts to the north-west of Northumberland, close to the Scottish Border. The College Valley appears as *Colledge* in 1542. Its meaning is not certain, but here are the alternatives: in Middle English a *letch* is a slow-moving stream and *col* means that it was cold. It could be where charcoal was burnt, 'Col's stream' or 'crows' ledge'. The College Burn runs south from the Cheviot itself to join the River Glen ('clean, beautiful, holy'). The valley is ice-sculpted and the hills smoothed over on either side. In parts the valley floor widens significantly.

Deep and long terraces were created for grain production and medieval rig and furrow systems for the same purpose wind their way down the slope, cutting through the terraces.

There are many settlements in the hills overlooking the valley – strongpoints and good lookouts. Two of them are called Great and Little Hetha, both looking to the wide valley floor where there are the remains of a stone circle that was a focal point for the meeting of prehistoric scattered farmers, a gathering place for ceremony and more mundane activities roughly 4,000 years ago, whereas the hillforts are probably built some 2,000 years later. Hethpool itself is a small settlement in a relatively wide part of the valley. On the east bank of the valley the large enclosure wall reminds us that in more recent times labour was cheap and readily available to those who were carving up the land for their use.

The valley widens sufficiently to bear grassland and to have farms built there. The Cheviot and Henhole come into view. These are the high points of the Cheviot range at the granite core.

From here we are close to the Scottish border on the west, and remain in Northumberland for the next area.

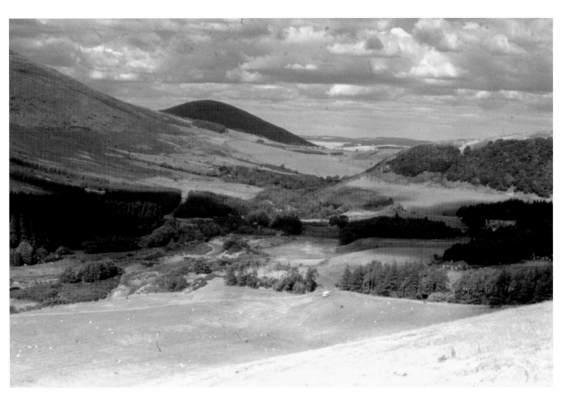

The north entrance to the valley is from Kirknewton ('the new church settlement') through a narrow gap and winding road to Hethpool and the Elsdon Burn junction, where there is a dramatic introduction to more ancient field systems, particularly terraces which cling to the hill slopes in great swathes.

The College Valley.

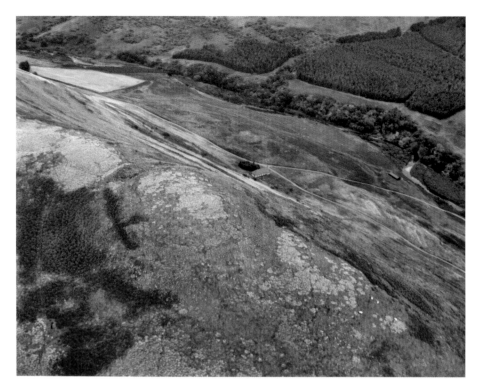

The Great Hetha hillfort is seen from the air, aligned with the valley.

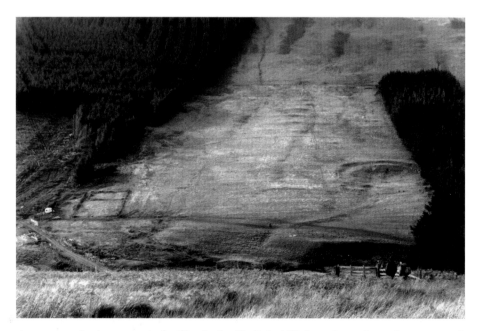

As we move further towards the Cheviot itself, all the hill slopes have signs of past use such as settlements scooped out of the hillside and, more recently, steep and very long drystone walls. On the west valley slope there are terraces and a large prehistoric scooped circular enclosure to the right with a trackway leading to it. Other enclosures appear to be later.

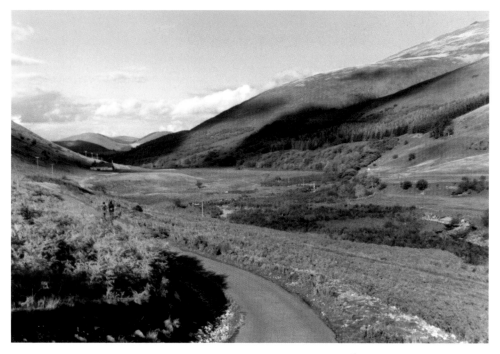

The College Valley has running water and verdant, wooded areas interspersed with gorse. The view, looking north, is from the southern end of the valley.

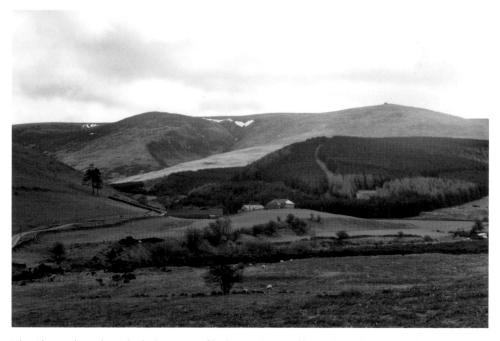

The Cheviot has a long, high sloping profile that makes it different from the other hills. On top it has thick marsh, with stone footpaths across it in parts. It was, however, the graveyard of some Second World War airmen who were stationed on the airfields of the Milfield Plain, and whose monuments in Kirknewton churchyard show how they came from many parts of the Commonwealth.

Kirknewton, Yeavering

The valley of the River Glen, tributary of the River Till, is one of our most famous historic sites, as the glacial terrace of Yeavering was used both by prehistoric and Anglian people. It marks the site where Paulinus reportedly baptised hundreds of local Christians on the orders of King Edwin, whose palace was situated there.

The palace, made of wood, at the centre of enclosures and meeting places, was recognised from crop- and parch-marks that showed up clearly from the air; they can still be seen at ground level as different colours in the field just off the main road. The River Glen runs through an area of gravel which provided a suitable level platform for settlements established long before the Anglians took over the site as a power base.

The edge of the Cheviot massif curves round from here via Akeld, Gains Law and Humbleton Hill to Wooler. All these sites were intensively settled in prehistoric times, with well-preserved remains. They fit neatly into the landscape, with a ravine, seen from Gains Law, leading up to Monday Cleugh.

People have always used whatever the landscape offers to make a living and to defend what they have. Humbleton Hill ('bare-headed or free of vegetation') is yet another example, The site was first used to build a large round burial mound some 4,000 years ago, but the strategic value of the site was seen to be the abrupt slopes that would deter an attack. Over a long period of time stone ramparts were added, two of them now crossed by a footpath. The Milfield Plain is seen below.

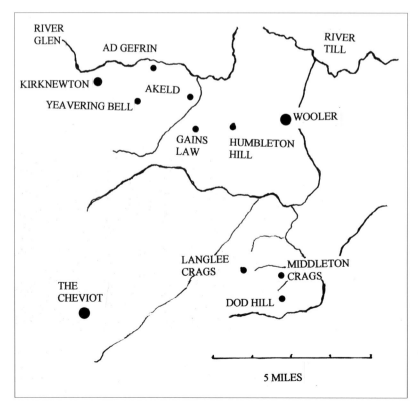

Map of the Glen Valley to Wooler. (SB)

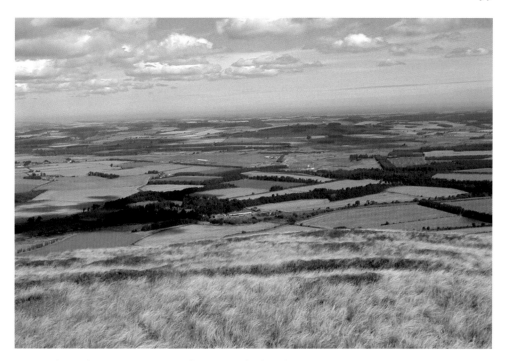

Rising above this site, Yeavering Bell is a superb place from which to look over the Milfield Plain and scarps to the North Sea, to the Cheviot itself and other inland hills.

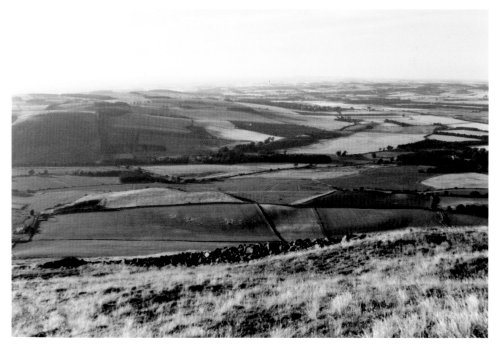

Looking down on the Anglian Yeavering settlement from the Bell ('hill'), the stone ramparts of the hillfort can be seen at the edge of the hill. This gives a clear indication of why the regional capital was built there.

The Name 'Ad Gefrin', from which Yeavering derives, means the place where there were wild goats. They have survived, and are well camouflaged in the centre of this picture taken in July, 1999.

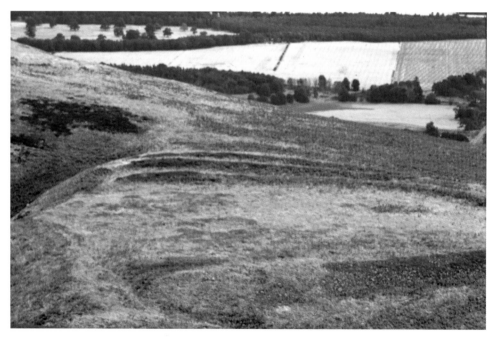

At the head of the 'cleugh' (ravine) is a 2,000-year-old enclosure that uses the steep natural drop as part of its defence. The rest of the Monday Cleugh enclosure are round-houses' bases within a curved wall.

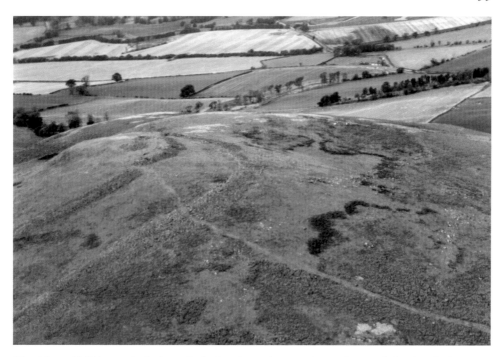

Humbleton Hill is particularly well-sited, using a deep ravine to form a defensive ditch as one of its natural defences; the rest are walls that were built over a long period, with an even earlier cairn marking the summit.

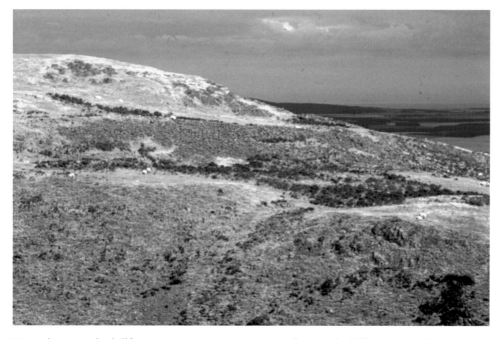

From the west, the hillfort was an important meeting place in the hills, protected by a natural ravine. Above it rise the ramparts made of thousands of stones.

One of the great joys of Middleton here is its colour in the autumn and winter. Not only do we see the effect of ice action on the landscape, but also the breadth of view to the sandstone scarps.

Further Glimpses

We have cut through the hills and valleys in many places, giving a reasonable cross-section of the Cheviot range, and what follows adds just a little more detail. As this book cannot be a complete coverage of the Cheviots, I choose some places and images that reinforce some of the things that we have already seen, beginning south of Wooler at Middleton.

1. Middleton
Middleton Crags on the east side of the Cheviot Hills, with the Fell Sandstone scarp running from north to south on the horizon.

2. The Alwinton Area
The small village of Alwinton occupies a special place on the fringe of the volcanic Cheviot Hills and the sandstone ridges beyond. Here the River Coquet, sometimes following the division between igneous and sedimentary rocks from its source in the hills, cuts a gorge at Barrow Scar and Barrow Scroggs, where a rare and more massive section of the Cementstones is visible running into a large open plain, before turning south with Fell Sandstone scarps to the west, meandering its way east to the North Sea.

 The difference between igneous and sandstone landscapes is very marked. One access to the Cheviot Hills is an ancient trackway known as Clennell Street, which descends south from the hills to Alwinton and is largely flanked by grassland and the remains of pre-Roman and Romano-British enclosures. Igneous rock sometimes pushes its way through the tops of the hills or is exposed on steep flanks, its twisted, colourful fire-formed material sometimes rolling down the hills as scree.

The photographs chosen from this ancient route alone typify so much of the Cheviot landscape – smooth-topped hills and a carpet of grass appreciated by flocks of sheep and, further north, forest deliberately planted as a cash crop. Narrow streams cut through the rock in steep valleys to flow south as feeders of the River Coquet, often looking like tree branches and twigs. To the east the narrow River Alwin makes its way to join the Coquet. Valleys are steep, with areas of grassland at the bottom on which circular sheepfolds are built close to patches of woodland. In the distance the granite core of the Cheviot is to be seen, where it favours heather and peat rather than grass.

The scenery to the south is that of the river plain and the dark heather-covered sandstone that runs south, overlooking Harbottle via Angryhaugh and the Drakestone. There is a skirt of grassland at the base of the Cheviot Hills, where sheep graze among the faint traces of rig and furrow grass-covered ploughland. From places like the hillfort of Castle Hill we can look SSW to the Coquet Gorge and beyond that to the hill-slopes to the north and south of the river. When we follow the river upstream on its changing course, passing the Cementstone cliffs, we enter a long valley that widens and shrinks with a beautiful variety of landforms and vegetation, sometimes marking the division of igneous and sedimentary rocks. Here the sound of gunfire disturbs the peace, for the river also marks the boundary of the military training area outside the Cheviot Hills.

This also marks a great change in landscape and vegetation; as we move further downstream from Alwinton. Steep Fell Sandstone scarps face east and run south, their dip slopes running into heather, marsh and some local millstone extraction at the prominent Drakestone, named after a dragon. The scarps overlook the settlement and castle at Harbottle, which is placed strategically to the west of the river, and we shall explore the river's course as it follows the scarps. We are then firmly outside the region of extinct volcanoes and lava flows.

Before leaving the Hills, though, we can follow them north-east to Biddlestone, where there is a dramatic intrusion into the andesite rocks. Harden Quarry is famous for its pink granite (mica-porphyrite), a late intrusion, used as a particularly attractive road and drive surface. It is about 1,200 m from east to west, with the quarry still working.

Hoseden Burn, to the west of Clennell Street, is a dramatic feature. It is fed by smaller, deeply-cut tributary streams like this. The name Hoseden (sometimes 'don') means that it is a valley with a hill or spur of land.

The northern part of the stream valley has timber planted in it and there is a sheep stell visible. To the south, the Hoseden Burn cuts through the hills to form a tributary of the River Coquet, where we now follow. Castle Hill, on the southern edge of the hills is a defended prehistoric settlement which overlooks the sandstone hills beyond the Coquet. Within the 'castle' andesite is exposed, and the view is towards the Coquet Gorge, where there is a sharp division between igneous rock and sedimentary Cementstone.

South of the volcanic hills there is grassland, with some faint rig and furrow indicating that it was once ploughland.

Now for some captioned pictures to illustrate this area.

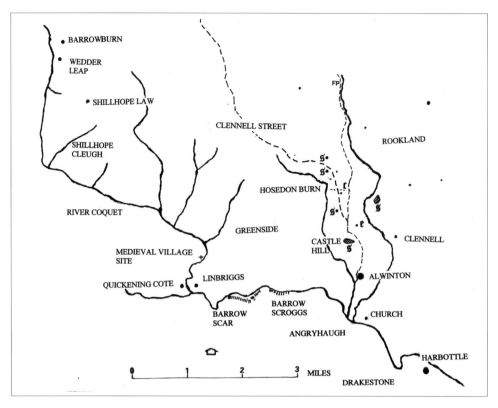

Sketch map of the Upper Coquet. (SB)

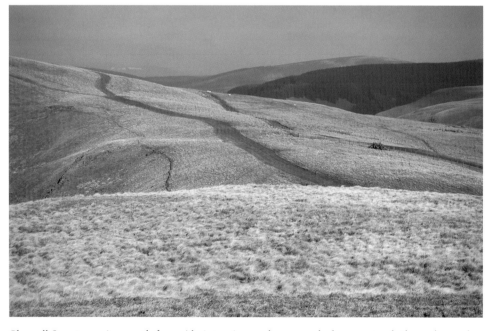

Clennell Street running north from Alwinton is seen here as a dark green track through rougher grassland – a characteristic of many parts of the hills.

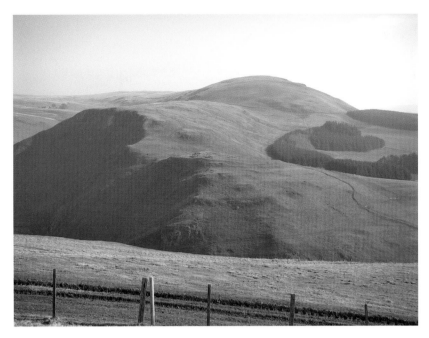

Clennell Hill (i.e. a hill free of vegetation), with its thin cover of grass, and steep north-facing valley, has a prehistoric enclosure on the promontory nearest the camera. An earth and stone-dump wall, formed by digging ditches on either side, runs across the track from west to east, towards Clennell Hill, and is known as the Cross Dyke.

Areas of level grassland formed ideal places for small prehistoric and Romano-British settlements amid the hills. One that has been excavated is at Hoseden Linn west of the Street, enclosing nine ring-groove houses within a timber palisade. Only the traces of foundations and low walls are usually found, as timber buildings rotted away.

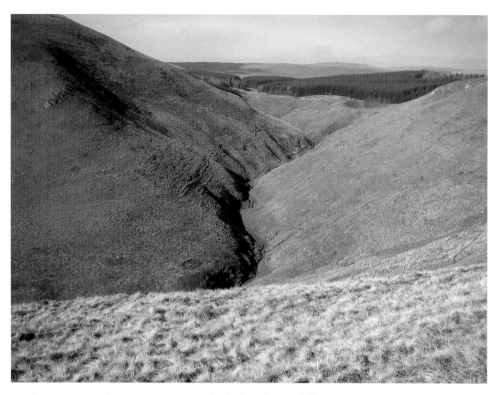

Further upstream, the Hoseden Burn is flanked to the north by a smooth, steep slope with some scree fallen from exposed outcrop rock.

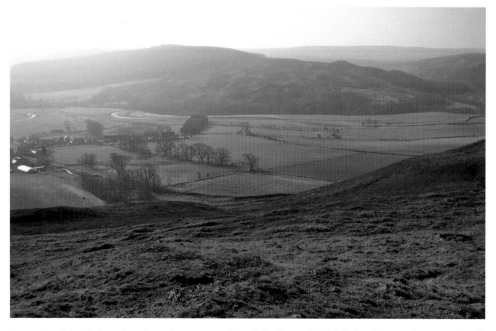

From Castle Hill there is a slope down to a wide plain through which the Coquet flows, with Fell Sandstone scarps appearing beyond.

The Coquet is flowing east, having broken through its gorge, with sedimentary rocks to the right (south).

Barrow Scroggs and Barrow Scar are Cementstone cliffs. They are the largest visible outcrop of these sandstones, shales and limestones, 115 m (150 ft) high. At the Kay Hill cliff west of this the sandstone becomes thicker.

The valley varies in width as the river flows from the north-west, giving room for small settlements or single farms like this at Barrowburn.

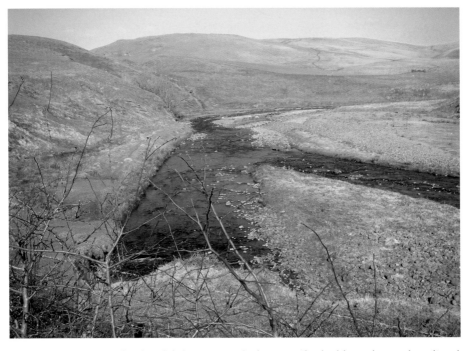

Meanders create grassland and fishing grounds, here overlooked by a deserted medieval village.

The bed of the Upper Coquet north-west of Shilmoor has large blocks of stone on its bed. Ground-up pebbles, locally known as 'stanners' are another feature of the river bed.

The river continues to follow the steep edge of the igneous rock, then turns north-west to Wedder Leap, Barrowburn, where there is a picnic area, from which two major footpaths lead to Windy Gyle on the Scottish Border and Hazely Law. The road continues to follow the course of the River Coquet via Windyhaugh, where a very small First School once operated. The road then turns west and leaves the Coquet Valley.

We return to the Coquet Gorge, with the Cementstones to the right. The river floor widens considerably, surrounded by higher ground, and the land takes on a more controlled, managed look. The road from Alwinton to Biddlestone looks towards the Cheviot Hills on the left and heads towards the Vale of Whittingham.

The western quarried part of the Harden/Biddlestone laccolith is visible above the trees. It is bright pink in colour and is used as a special road or ornamental surface.

2

Sedimentary Rocks

What follows now is a general account of the formation of rocks outside the Cheviot area. When the volcanoes stopped erupting and cooled down, the hills were slowly eroded and their debris was carried to a shallow sea and deposited there as sand, mud and boulders, rather like what we see in miniature in a river bed. Among the debris were conglomerates that contained pieces of igneous rock, but most of the material was sand and shale in water-borne deposits that we call Cementstone. Here the various elements were 'cemented' together. Over millions of years there were periods when shells of dead sea-creatures and algae (rather like seaweed) sank to the bottom and the calcium carbonate (as in chalk) formed thin beds of limestone, so the Cementstone has lenses of material other than sand and shale in it. Much of the county close to the Cheviot Hills and spreading further away is made of this.

In places the sandstone thickened as sand and mud built up at the same time as the sea floor sank. The bedding of these layers changes, and we can see this clearly in exposed sections, especially in the Fell Sandstones, which were built up in a huge river where the flow was not constant. Changes in the ebb and flow of the water also left different deposits such as lime and different kinds of fossils. In the delta of this vast river vegetation decayed and formed peat which was then compressed by more weight and became coal.

What we now call Carboniferous includes shale, sandstone, limestone and coal, and this series covers most of Northumberland outside the Cheviot Hills. Whereas some of the limestone is in thin lenses, to the south of the county it becomes massive; it was deposited as shells in warm, shallow seas where they did not have silt constantly emptied into them; shells can build up limestone hundreds of metres thick. It wasn't a case of just one succession of deposits in an orderly sequence, for coal, limestone, shale and sandstone can occur at any level in a cross-section of the earth.

The Limestone Group has about thirty different limestones of varying thickness, and this shows that the process of deposition is anything but simple. They lie in bulk to the south where the warm sea was, with the land to the north. The different deposits are marked by the kind of fossils found in them as well as their colour, texture, and bedding. In the north they are more widely spaced, and often appear locally, as at Ottercops. At Ingoe, Rothley and Shaftoe sandstone grits appear within the limestone. So although there is a general spread of deposits that form scenery, we always have to be aware of these local variations, which often produce marked changes in the landscape.

Millstone Grit is so-called because you can see many different sized grains in the sandstone, deposited by huge rivers.

Within some of the shales are Ironstones forming the basis for some local industries such as those around Bellingham.

However, sediments are deposited, their layers can be dramatically disturbed by earth movements that produce faults and slide out of a horizontal position, or buckle. The Pennines were thrust up during one of these powerful movements. At a local level, compression, tilting and uplift produce variations on the land surface. These forces were brought up by movements from below, but the most spectacular movements are when molten rock is forced to the surface where it cools. In Northumberland Dykes are formed when this molten rock follows faults caused by earth movements, so we see pillars of whinstone all over the county, generally in an east–west direction, often marked by the quarries that exploit it as road metal because of its hardness, or by a change in scenery like the outcrops at Bamburgh or Dunstanburgh on the coast or inland in the Hadrian's Wall corridor.

It was ice that finally moulded the landscape, moving southwards, submerging the county under a huge glacier from the Scottish Highlands. The glacier crushed, gouged, scratched and smoothed rock as it moved slowly along with the rocky tools that it carried, and when it melted it left tonnes of material behind. At Milfield it formed a huge lake and filled it with deposits. When it eventually dried out, it had left behind a complex series of silts and gravel that provide early people with a place to live, modern industry with a rich source of aggregate, and farmers with good arable land.

The ice also changed the course of some rivers, although generally these predate the Ice Ages. The Aln and the Coquet were able to cut through the Fell Sandstone through faults, flowing east to the sea, but the Breamish had to follow a northern course between the sandstones and cut through a gap to reach the Milfield Plain before reaching the sea via the River Till. Only the small streams between Berwick and Alnmouth reach the sea directly, and they do so off the dip-slope of the Fell Sandstone scarps.

Indications of the different kinds of layers that form landscape are widely scattered as small coalmines, limekilns and limestone quarries. The land has been exploited locally not only for what can be cut down and ploughed but also for building materials. In some parts ploughland has been abandoned or turned to grassland, and the county abounds in remains of these. There are hundreds of 'deserted' village sites which show how farming and settlements have changed. The more familiar we become with local landscapes, the more we see of these subtle changes. In some of the most isolated and bleak parts of the military ranges, for example, these old settlements, from prehistoric times onwards, are protected by signs that they are sites of archaeological interest, and are thereby protected even from gunfire and manoeuvres, as they are on Salisbury Plain or County Durham. Paradoxically, they are kept safe. This protection also extends to flora and fauna.

The military zone includes large Roman 'practice' camps, and in more recent times the army sent young men to practise trench warfare in zigzag ditches that for many were their last movements on English soil.

It is a poignant and sad place, made bleaker by the general terrain. There is a great contrast between the 'dark' land of these acidic sandstone soils and the shallow 'light' grassland of the Cheviot Hills. Northumberland owes its scenery to many episodes of geological time, and this book continues to follow this story visually in more detail.

Otterburn First World War trenches that prepared young men for trench warfare.

A. Fell Sandstones: the Scarplands

Outside the volcanic area, the Fell Sandstone scarps have a very distinctive profile. Beginning in the north, and swinging south-west to the west of Alnwick, they have been thrust up by earth movements and form not only good sources of quarried stone but also once provided prehistoric people with thin soils that were adequate for light scrub, woodland and pasture and with high places where secure enclosures could be built, animal stockades, and sites for their burials, though their main settlements were on lower ground. The direction of routeways on the tops of the scarps often gave clear visibility and the dip slopes opened up land that was good for hunting and pasturing animals.

Examples are chosen from the main scarps that form the rim of an upturned basin.

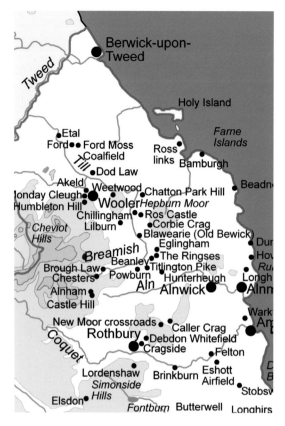

The scarp on this map forms an arc from the north of Dod Law to Chatton, Old Bewick and Alnwick, then turns south-west to Rothbury and beyond. (Marc Johnstone)

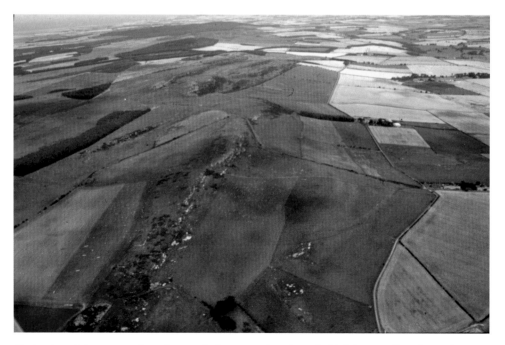

Cockenheugh is a scarp of sandstone, facing west, the edge of which has small rock overhangs.

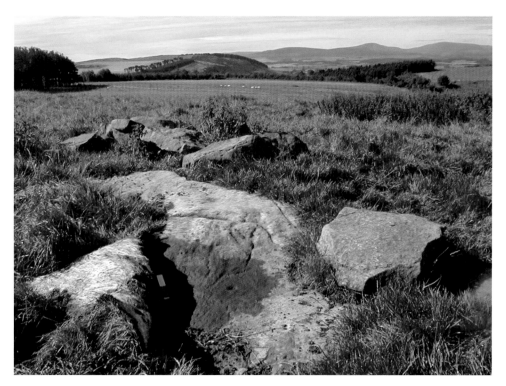

Lyham with an exposed panel of prehistoric rock art looks towards Chatton Park Hill.

Chatton Park Hill, with its dramatic rock art in a rock overhang, other major prehistoric panels, and an Iron Age settlement, has the timber-covered scarp and the dip slope used for industrial extraction and farming.

Further to the south, Ros Castle, a prehistoric enclosure, rising high above the rest, has some of the most extensive views over a very thinly settled landscape

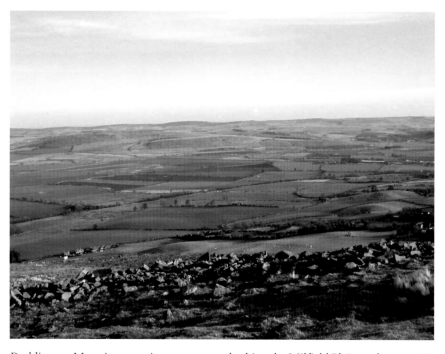

Doddington Moor is a prominent scarp overlooking the Milfield Plain to the west. We see it from Humbleton Hill.

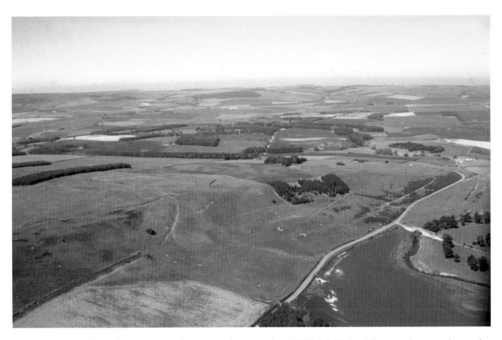

The Weetwood/Fowberry scarp faces north over the Milfield Plain. The road runs along the bottom, leading to a gap where the River Till breaks through from the east.

Beanley Moor is another very important ancient landscape, preserved among some tree plantations and rough grazing. There is a small prehistoric enclosure in this picture, with the view towards the Alnwick-direction scarp.

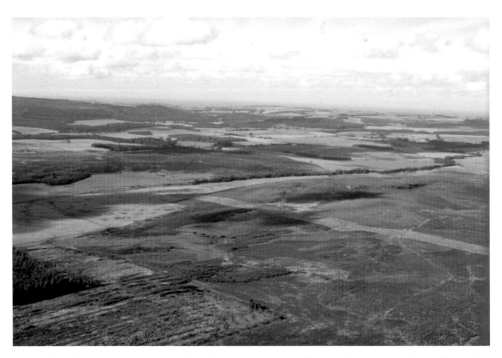

Hunterheugh is a continuation south of Beanley Moor, with a similar mixture of rough grazing, sandstone outcrops and prehistoric settlements, along with a buried gas pipeline.

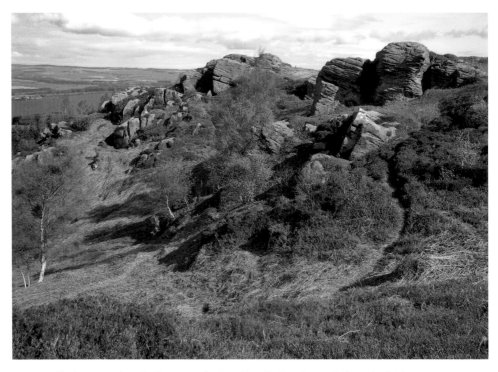

Lamp Hill: the scarp face looking north. On a level of rock just below the highest point are six prehistoric cup-marks arranged in a domino pattern at a significant viewpoint.

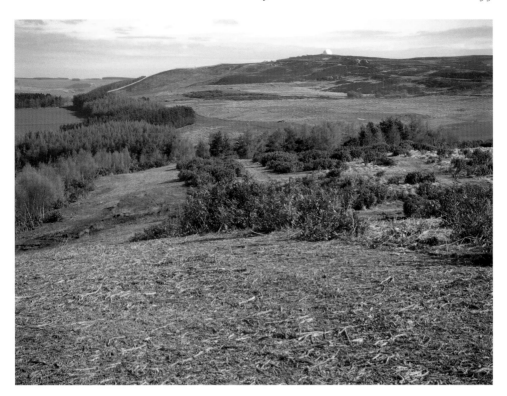

The change in direction of the scarp is seen here from the recently cleared ground to the 'golf ball'. The ground will now be able to grow birch trees, grass and bilberries, all of which like the thin, acid soil.

The Fell Sandstone scarp runs north to south at first, as we see above, its dip slope towards the coastal plain, broken in places by streams and rivers. It is so high that it forms a dominant ridge that overlooks most of the county. The scarp swings to the south-west in the Alnwick Moor area, roughly followed by the Alnwick–Rothbury turnpike road that uses its line as a main routeway. Its change in direction may be seen from far away at the radar station 'golf ball'. One of the most accessible viewpoints in the surrounding country is at Lamp Hill, which is easily reached by a gate and footpath just beside the crossroad to Whittingham and the A697 off the Rothbury road. The thick cover of rhododendrons has recently been thinned so considerably that it makes this one of the best places to see the landscape, illustrated by these photographs taken in May 2011.

Lamp Hill stands high above land to the north and north east, giving uninterrupted views over farmland.

Thrunton and the Vale of Whittingham further north continue outcrops of sandstone, and its streams feed the River Aln. The vale is rich farmland, different from the Fell Sandstone. A west–east Roman road runs along the valley as well as the River Coquet. Cementstones mark a division between igneous rocks and the Fell Sandstones, and today a road that links Glanton with Alwinton follows that division.

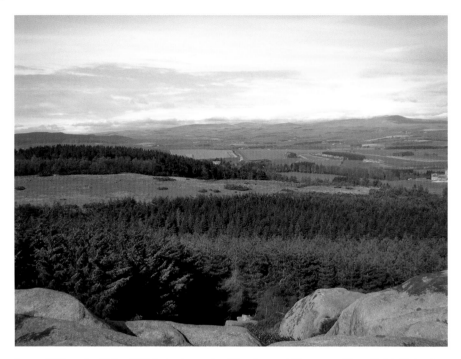

Lamp Hill to the Vale of Whittingham, the Cheviot and Thrunton Crag (left). This view encompasses scenery formed by igneous and Cementstone sedimentary rocks.

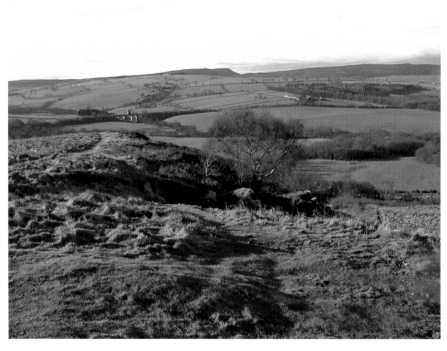

A little to the south-west, Corby's Crag gives a superb view north over lower land where Edlingham, an abandoned railway and a turnpike road make use of the valley.

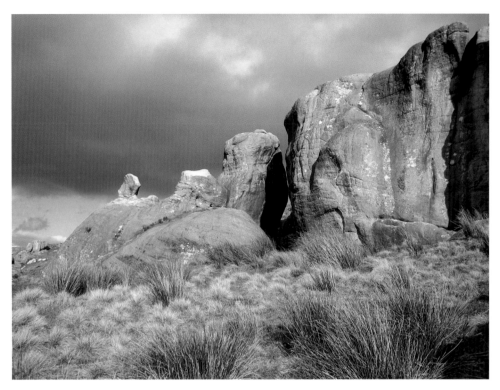

Caller Crag overlooks Thrunton Crag towards the Cheviots.

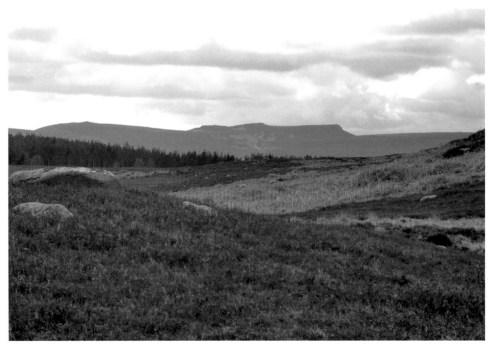

Simonside, seen from Debdon Whitefield, just off the Alnwick–Rothbury road, is a major feature in this landscape, visible for many miles.

Simonside, overlooking the Coquet Valley and Rothbury, is a highly visible ridge from many directions. Here it has a background of a prehistoric carved rock with commanding views.

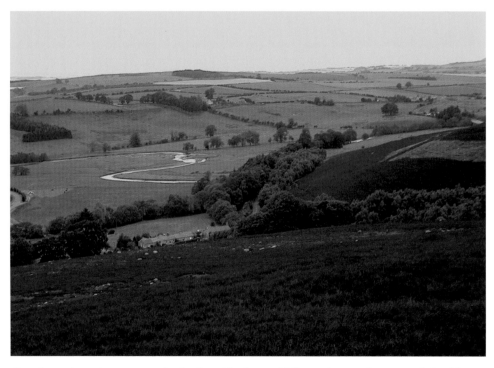

Grasslees, where the scarp overlooks the wide Coquet Valley as it meanders towards Rothbury.

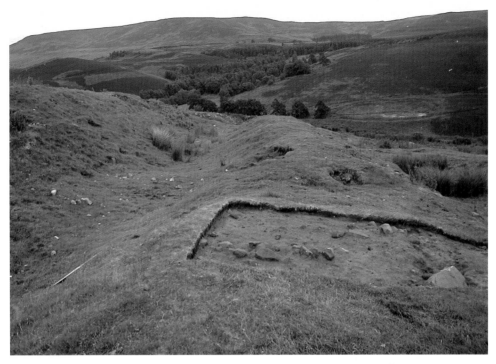

Harehaugh continues the Simonside sandstone range over the west bank of the Coquet north towards Harbottle Castle and village. Its multiple ditches and ramparts have recently been partly excavated and some efforts have been made to deal with the rabbits that are destroying them.

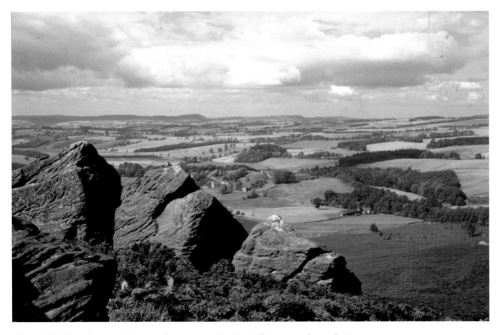

Above Harbottle, massive sandstone overlooks village, castle and river.

We return now by the river to the place where it turns eastward towards Rothbury, a plain where there is a gravel bed exploited as a quarry at Caistron, full of agates, and now partly flooded to make a bird sanctuary. All around are sandstone hills, most of them with defended prehistoric settlements on the summits.

We leave the Coquet here and follow the Fell Sandstones west to where Elsdon was a crucial routeway for drovers and a strategic centre with Norman castle, a medieval defensive tower and church. As you approach the village along the straight road from the north, you descend into a narrow stream bed which determined the site of the Norman earthworks known as The Moot Hills, a motte-and-bailey castle that was not rebuilt in stone, thus preserving a prefect plan. The scarplands open up to a low-lying area for a while where the old rig and furrow systems of ploughing are clear in slanting sunlight, and the village is the centre of a circular gathering place for the animals on their way to the fattening pastures and sale further south.

During the miners' strike in the Thatcher era, the small private coal mine was much in demand, and reminds us that there are many other small coalmines that closed once the richer seams in the south-east opened up.

We now look at other parts of the Carboniferous landscape that includes the Fell Sandstones, but generally not so prominent.

B. Cementstones

The south of the county has high moorland and some bleak areas on the edge of the Pennines that have been described as a natural wilderness, but its appearance is also due to the exploitation of minerals, especially galena for lead smelting. The rocks are sedimentary, including sandstone, limestone and millstone grit. This 'wilderness' appearance is also experienced on the army ranges at Otterburn and in the forested area of Kielder and Ray Burn. The discovery of minerals such as ironstone and coal has made a difference to the way places are settled; we see that Bellingham in the North Tyne Valley once had an extensive but short-lived iron industry powered in part by water from the Hareshaw Linn waterfall and locally mined coal. At Ridsdale on the A68 the castle-like iron smelter, surrounded by many spoil heaps, provided iron for some of Lord Armstrong's gun manufacture. Eventually the major industries moved to the Newcastle area and sources of iron came from overseas. Spoil heaps around Bellingham give an idea of the extent of mining for ironstone and coal in short-lived industries.

As there is such a variety of layers of rock, some features stand above the rest. For example, there is a series called Ingoe Grits, with larger grains than in other sandstones, the site name being an indication of a ridge (*hoh*), an element also found in the names Cambo, Prudhoe and Sandhoe. Ingoe Grits are found in mid-Northumberland, and two other examples of such prominent ridges can be seen at Rothley and Shaftoe.

As I have dealt extensively with Shaftoe in other works, this section will concentrate more on Rothley, where the land was developed by Sir Walter Calverley Blackett, owner of Wallington Hall in the late eighteenth century. He built monuments on the crags at Rothley, one called Codger Castle, the more northerly rise. The rocks are extensively

quarried for their sandstone, which is made up of grains that varied between the size of small pebbles and pinheads. Not as high as the Fell Sandstone scarps, they still provide a striking ridge extending many miles.

Codger 'Castle' is a folly at the northern edge of the outcrop overlooking a dammed valley that has lakes on either side of the Rothbury road, planned by Capability Brown. Deciduous trees have been planted to make the valley attractive, but the hill remains as raw stone and thin grass. To the south close to the little settlement of Rothley there is another castle-like construction built in the 1750s with a central tower and wings with smaller towers at the ends. On the same promontory is an earth and stone wall enclosure that is probably prehistoric which has extensive views to the west. Elsewhere, there are signs of intensive quarrying, hollow ways and other tracks, while below on the richer soils there are many deeply rig and furrowed fields of an arable farming system.

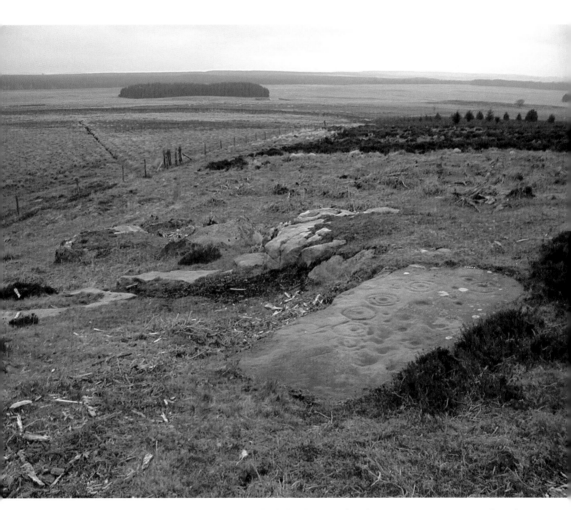

Ottercops Moss is a scarcely-populated, bleak landscape, but here we see outcrop rocks of sandstone some 305 m (1,000 ft) thick decorated in prehistoric times, obviously of importance to people using this area. This series continues to the Cumbria border and to Scotland.

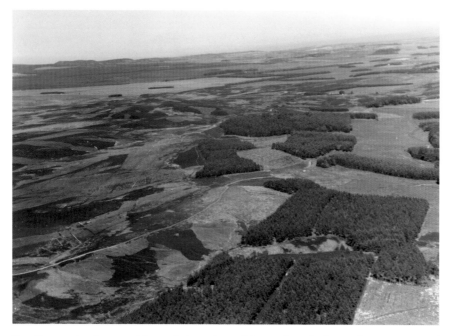

Ray Burn: a landscape with a subtle variety of forms, largely devoted to pasture and to growing timber. This view covers an area towards the Simonside Hills.

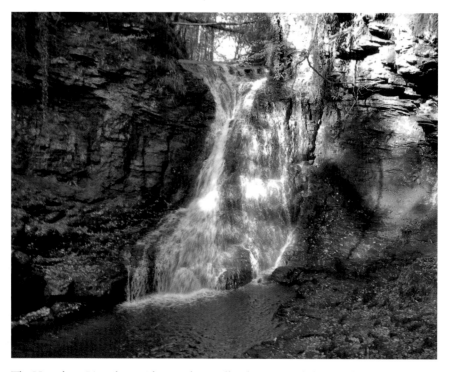

The Hareshaw Linn (hare-ridge-pool) at Bellingham provided water for bellows in the iron industry and is a popular beauty spot.

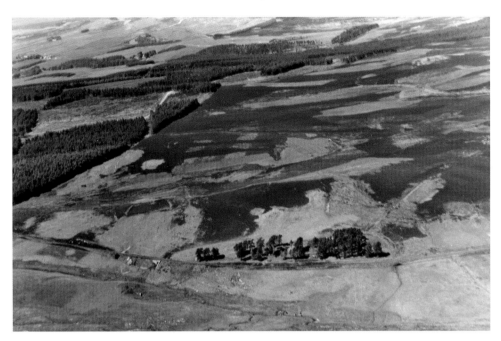

Buildings are few and far between, yet this picture shows the abandoned railway that marked the opening up of remote areas in the nineteenth century. It also brought people from all over the world to view the demonstrations of Lord Armstrong's guns.

The Ridsdale iron-smelter: seen from the A68 the fields around the smelter have narrow rig and furrow although much of the landscape has extensive quarries. The Ridsdale iron-smelter, with piles of iron slag around it, was abandoned in 1848 after only twelve years of use.

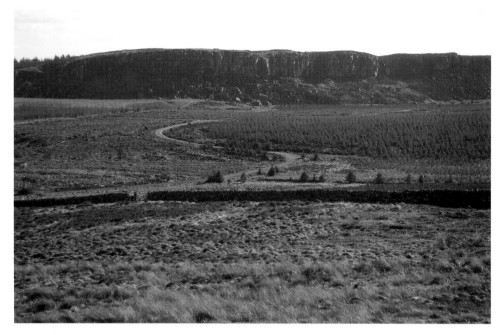

The Wanney Hills, just east of the A68, is another notable outcrop of sandstone, celebrated locally in music, especially by the Northumberland piper, Kath Tickell. It lies close to Ray Burn and to the Sweethope Loughs.

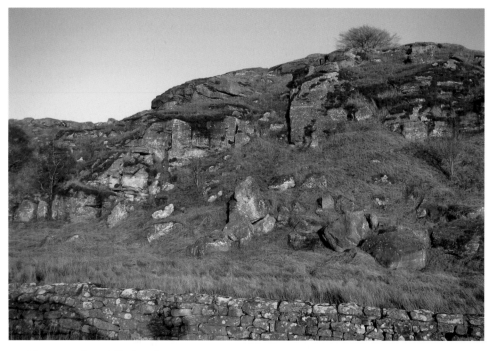

Rothley Crags has cliffs that face east, the ridge continuing towards Capability Brown's lake at Rothley. This ridge has attracted settlement, defence and a folly. To the east the land levels out into a tract of rather unproductive soil.

A castle on Rothley Crags, with Simonside on the horizon.

At Shaftoe there is a remarkable landscape of high rock that is deeply dissected. The view towards Wallington includes an ancient drove road that crosses the ridge through a gap. Some spectacular rock formations overlook a narrow valley where recent excavations have exposed rock-shelters of prehistoric people living in them over 8,000 years ago as well 4,000-year-old rock art, and enclosures of the pre-Roman and Roman period.

Moving further south, where local lead-bearing limestones become prominent, Hexhamshire's farmland gives way to grouse moorland, where heather predominates, quarries are many and the landscape seems all but deserted by people. The area around Blanchland, although largely grassland, had sufficiently fertile farmland to attract a monastic settlement in a valley as well as serious exploitation of lead ores. Lilsburn Moor, south Hexhamshire, is typical of heather-covered grouse moor. Blanchland: the snow has picked out the intensive use of this landscape, with drains and field patterns from many periods.

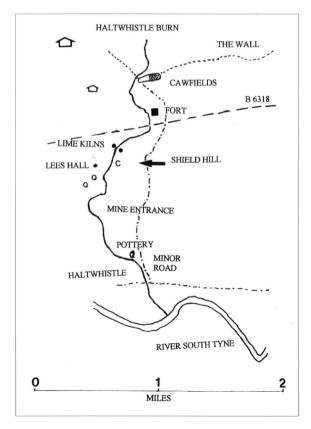

Map of the Haltwhistle Burn.

Haltwhistle Burn is an excellent place to see the various layers of sedimentary rocks, where they have been commercially exploited. The name means a high place that overlooks the junction of two streams. The burn runs south from Cawfields, overlooked by the quarried Whin Sill where the Roman Wall has been left in the air. The quarry began in the mid-nineteenth century and closed down in 1952 when it was eating away too much of the Roman wall, leaving behind a space used as a car park beside a deep lake. The hard stone was taken by waggonway mainly along the burn to Haltwhistle in the south, where it was transported by rail to various places that needed roadstone along the Newcastle–Carlisle railway.

The dip slope of the basalt scarp to the south gives way to underlying sedimentary rocks of the kind that we see exposed in the Haltwhistle Burn further south. Here is a relatively low-lying area, divided by the Roman Vallum, which is covered with temporary Roman camps, to the west of which the burn flows below an early fort of the first Roman frontier, The Stanegate. From here the scarps of sandstone sweep in from the east, and are nibbled along their courses by small quarries, some of them possibly Roman for use in wall building.

Across the Military Road, built in the eighteenth century, the Haltwhistle Burn cuts a deep gash in which we can see sandstone, limestone, shale, ironstone, coal and fireclay as well as the remains of some of the industries that worked them. It was truly a 'working valley' with access today by footpaths. The minor road from the Milecastle Inn south to Haltwhistle has footpaths leading to the east high bank of the burn, itself too steep for access, but on the way it is riddled with quarries that show how the land was formed.

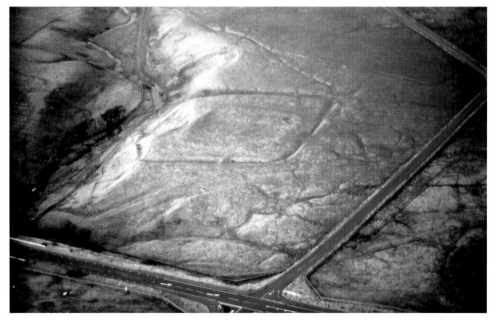

The Roman Wall at Cawfields, above, with the Haltwhistle Burn early fort to the left. Whinstone gives way to sedimentary rocks that have created this landscape.

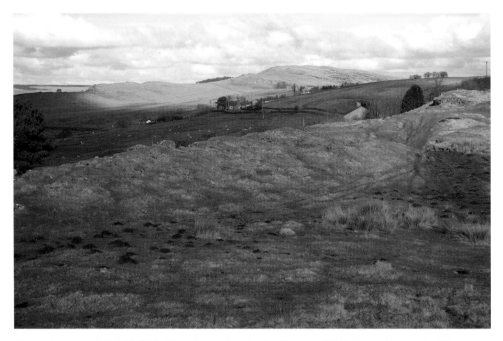

From the top of Shield Hill this view takes in the Roman Wall from the south. The name means that there was a shieling, a temporary herdsman's hut. The Haltwhistle fort is central above the valley.

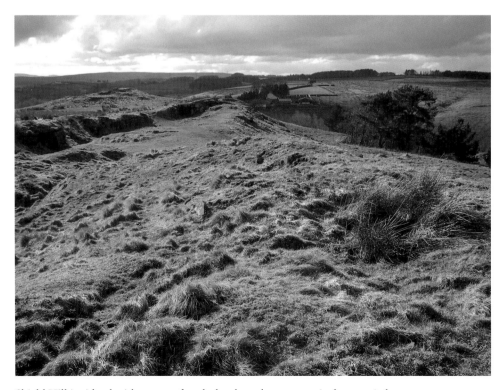

Shield Hill is ridged with seams of rock that have been extensively quarried.

This ridge ends at the burn, with Lees Hall farm in the picture.

The sandstone here rests on a bed of shale and coal.

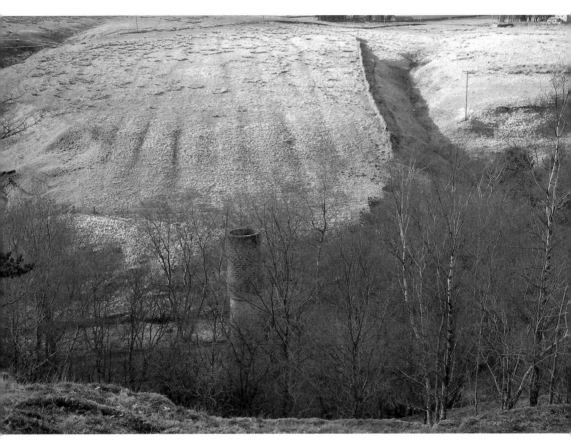

From the east the chimney of a colliery can be seen in the wooded valley on the opposite side of which are wide steam-tractor-ploughed rigs.

The usual access to the stream is on its west bank, much of its being the old railway line. There are lime kilns on both banks, followed by the remains of a colliery – the chimney and engine block. A footbridge crosses to the west bank, where there is a big exposure of sandstone and shale in quarries. On the west bank the Leeshall quarry has a thin sandwich of coal between thick sandstone, followed by an exposure of limestone.

On the east bank beyond a picnic site a large quarry exposes shale and sandstone above limestone, where there are the remains of a colliery drift mine into the base of the cliff. Alum comes out of the water from this; the mine produced coal and fireclay, where there are remains of pottery kilns. A row of miners' cottages marks the exit to Haltwhistle village.

We now view these features, beginning on a walk from Cawfields to the Military Road, then across to the west side of the Haltwhistle Burn, which is steep, wooded, with fine exposures of the underlying rocks which have been commercially exploited. Just out of Cawfields, the burn has spoilheaps on its east bank, above which is the Roman Stanegate fort.

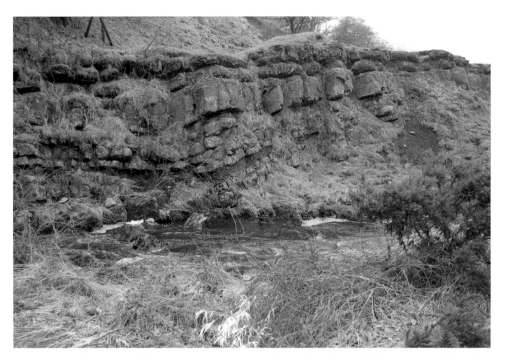

Across the Military Road, the path enters a steep valley, where the rock layers are visible in the east bank: sandstone, shale and limestone.

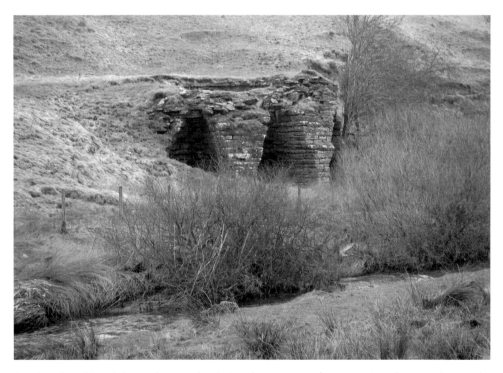

An abandoned limekiln on the west bank, in a better state of preservation than another on the opposite bank, shows how local limestones were used in the production of vital agricultural lime.

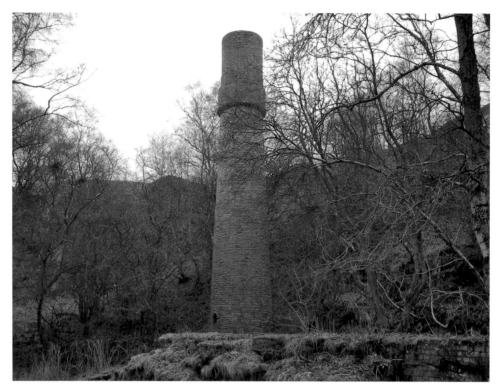

A colliery chimney and its engine bed on the east bank show how small coal seams were exploited before the move to larger seams in the south-east of the county. Many trees mark its abandonment, but also add beauty to the valley.

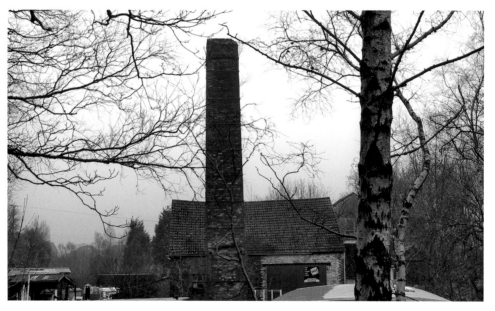

Fireclay was later mined instead of coal, and here we see the old pottery that fired it, now used as a timber yard.

To the Scottish Border

Anyone driving north along the A68 through Northumberland to the Scottish Border is following the course of a major Roman road, Dere Street. It is obvious that there are considerable rises and falls in the land with ridges and valleys like a roller-coaster. Outcrops of sandstone are often marked by quarries and their heaps of spoil, especially in places like West Woodburn. Another feature is the amount of grassland which, when the sun is low in the sky, throws up acres of medieval and more recent rig and furrow ploughing, abandoned and grassed over. The latest of the eighteenth- and nineteenth-century 'improvements' in agriculture when more grain production was essential, with walls and hedges marking rectangular fields that are not prevalent in open moorland. There are many forests, too, of planted conifers, and dammed-up streams that form large and small reservoirs. Today the area around and beyond West Woodburn is still sparsely populated and even the presence of frequent prehistoric enclosures does not point to a large population in the past, either. There are far more sheep than people.

Nearing the Border, the land rises and becomes colder, the sour soil adding to the inhospitable expanses of moorland and marsh. Here streams cut the valley sides to empty into small rivers such as the River Rede, which joins the North Tyne to flow further south.

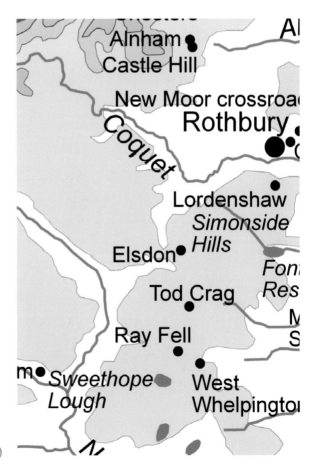

The map shows the position of Tod Crag (Ottercops), Ray Fell and Sweethope Lough. (Marc Johnstone)

I have chosen specific areas of this landscape to represent a much wider phenomenon of land that is made up of sedimentary rocks that cover so much of the county, yet the order in which the layers appear and the forces that have acted on them make differences to what we experience. Before reaching West Woodburn, we branch off to the east on a minor road that runs to Sweethope Lough, an artificial creation. Crags rise from the coarse grass, bent and pasture, their quarried and exposed sections showing that this is sandstone. Streams gush from 'the rises'. The views are breathtakingly extensive, the farms few, the chances of meeting other people are slight apart from the occasional forester, farmer or shepherd, yet across the land from east to west ran a railway, still traceable, that linked small communities an enabled beasts to be moved to markets, a role replaced by road transport. We head back to the A68 south of Ridsdale to West Woodburn. The Simonside Hills and the continuation of the Fell Sandstone ridges is visible, and the road leads to the Border in the north-west. The area lies on the fringes of the Military Ranges, which occupy so much of the Cementstone country. The vast expanse of the Kielder Forest and its huge reservoir are another fringe. An appreciation of this exhilarating land will come from the photographs offered.

Sweethope Lough, the result of damming a burn, is in the background, surrounded by trees. The sandstone crags above it are typical of many in the area. Some of the hundreds of sheep in the area graze on coarse grass.

Crags like The Wanney Hills, named at the headwaters of the River Wansbeck, outcrop in many places. Here the rock face has been quarried, and the area leading up to it is commercial forest.

The Hepple Heugh ('rose-hip cliff') rises from heather and grass.

From the slopes of Hepple Heugh the Simonside Hills and the continuation of the Fell Sandstone scarp can be seen in the distance. Above the minor road running north-west to the A68 heather and clumps of grass give way to pasture and a ridge of sandstone. There are few farms, and an old abandoned railway runs below them.

From the north we look down on West Woodburn, with more rig and furrow, to the Wanney Hills.

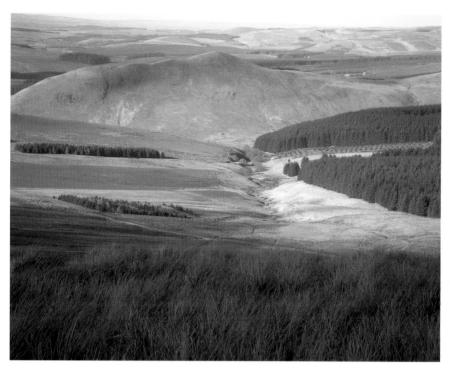

Carter Bar on the Scottish Border gives a marvellous view over the Cheviots. Here on the Scottish side is Knock Hill, at the junction of igneous and sedimentary rocks.

The sandstone vegetation of bent, grass and planted timber is crowned on the horizon by The Cheviot itself, as we look along the Scottish Border.

The underlying Cementstones clearly show here with a poor-quality soil that supports only bleak vegetation, often marshy. The valley ahead is that of the upper River Rede.

The upper Rede valley seen in dramatic light, one early spring afternoon in 2011.

3

The Milfield Plain

Although the coast has extensive areas of low-lying and fairly level land, the Milfield Plain is a rare large expanse formed largely by ice and water deposits, with gravel not only being extensively removed for sale, but providing archaeologists with the opportunity to excavate a whole range of occupations from the earliest people in the area to its use in wartime for an airfield.

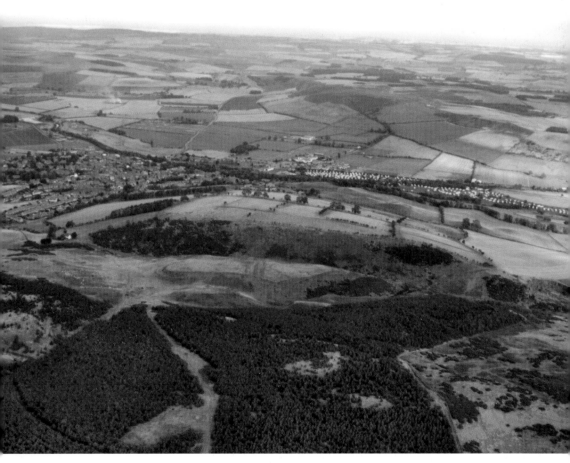

The Milfield Plain forms a significant gap between hills and scarps. Here we see it from the height of the Cheviot Hills.

The stripping of its surface by aggregate extraction gave archaeologists working with Dr Clive Waddington the opportunity to excavate large areas. Among multi-period sites, the discovery of the foundations of Anglo-Saxon houses is one instance of how important these discoveries are, as we know of the sites of two major wooden 'palaces', but, until recently, little about where the ordinary people lived.

The Plain was chosen in Prehistoric times for the erection of lines of posts and for the construction of many henges – circular ditches with one or two entrances, upcast around them to form a collar, and a ring of posts inside. Here one has been erected on the plan of one excavated to the north, using primitive tools.

Not only did people live here, but it was also of great importance for the building of monuments which established their ancestry, beliefs, and rights to the land; these monuments included many burial constructions like this one at Milfield West, where a ditch encloses pits filled with cremated bone.

To the east, the Plain ends at sandstone outcrops and one hollow way and track leads to the largest rock-art panel in England at Roughting Linn towards the coast.

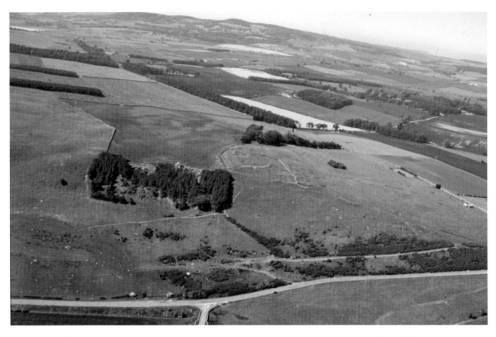

To the south, the Plain reaches the sandstone ridge of Weetwood Moor and Coldmartin.

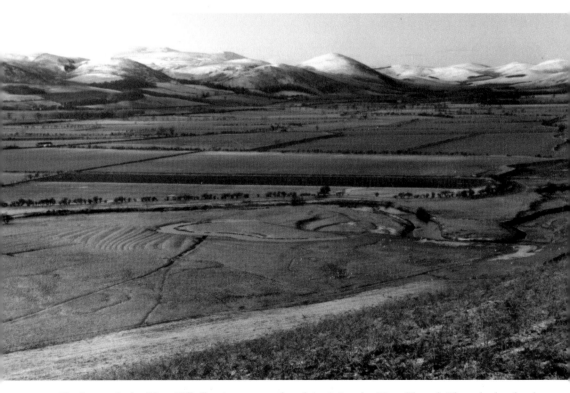

To the north the River Till, flowing across the plain, joins the River Tweed. Thus the lowland expanse provides a meeting place for routeways in many directions as well as a varied agricultural landscape, of the type we see here between Gled Law and the Cheviots.

4

The Pennines

The 'Backbone of England', the Pennines, is well represented in the south-west of Northumberland, which shared the prosperity of lead mining with its adjoining counties. The industry is well documented, and this account will concentrate on how its presence is still to be read in the landscape. Like so much local history, it is as important to look for it in changes to the land as to read about it. The industry extends beyond the Pennines to places along the River South Tyne, such as Langley and Haydon Bridge, but the major sites are around Allenheads, now with its dedicated information centre and a program of conservation of what remains.

Limestone in the Pennine region contains lead ore (galena) mixed with other minerals, injected into faults and fissures by fluids containing them. Usually these veins are vertical, varying considerably in width, and spaced out widely, so they do not cluster conveniently for mining. This meant that the miners had to spend considerable time and investigation to find suitable workings, and led to some important papers on geology being produced in the nineteenth century to help with the search. It was quite different from the concentration of seams that we find in coal mining.

Initially, if miners thought that there was a vein, a technique known as 'hushing' was used, in which a large body of water was dammed at a height, and released to wash vegetation and soil off the suspected vein. This identified the vein so that it could be worked, and signs of this method are still visible. The mining method was to use shafts and galleries. The early mines were pits dug along the vein, until the more efficient method was adopted of approaching the vein along a level and mined from below; this also ensured good drainage. At Coalcleugh in 1765 there was a level 1 mile long that had a horse-drawn waggonway, although some mines were still entered by shafts. The actual mining was largely a matter of muscle power, although the miners were helped mechanically. The ore was brought to the surface and taken to be 'dressed', but the disposal of the waste, or 'deads' was a big problem. One feature of the mining operation still visible is the amount of waste that has been dumped; it is everywhere – the sides of valleys and small streams, hills, for example, now covered with coarse grass. It was better to bring the 'deads' out of the mines in case there was need to explore and exploit the mines at a later date. It was obviously easier when the horse-drawn wagons brought the waste out.

The next stage of the operation was to take the ore to the washing floor, where the rock was broken up and the useful minerals extracted. Lead ore is heaviest, and sinks to the bottom in water. For this, a constant supply of water was needed to sieve it, and again artificial manipulation of the land and its drainage to produce this has left

its mark. After the washing and the removal of impurities through sieving, the lead sulphide (galena) had to be converted into lead through roasting and smelting. There are some remains of the smelters, but more dramatic are the chimneys that received the fumes from the smelters along tunnels (flues) that took toxic material away from the smelters, as it became clear that the danger of poisoning animals, people and land was considerable. These tunnels, constructed of sandstone, would also collect any lead trapped in the fumes and could be scraped off. Basically, the galena was heated in a blast of hot air, which left the lead behind. Fuel had to be available in the form of peat, coal and wood, either local or brought in. Water supplied the power for operating the bellows. Ore and fuel were mixed in special furnaces and were set alight, and the hot lead was ladled out from a pot into 'pigs' or bars. The whole operation was highly skilled.

In the Allenheads area we can see examples of all the stages of lead production. The settlement itself did not exist before the industry, and the village was built in a valley. Other houses are scattered around on valley slopes. Obviously the village had to be close to the mines, and these settlements were so high up that some people lived higher in dispersed houses than those in the Cheviot Hills. At Allendale we see that houses were built along the sides of the river and its tributaries. The 'village' itself had shops and an inn, and that was where the mining offices were. We can see from old maps how Allenhead expanded by enclosing the land. There was plenty of stone to build houses, and those remote from the main settlement were more like small farms. Their remains can be seen spread across the moors, and in their time the houses were considered much better than those of coal miners. Apart from the fumes from the smelt mills, there was little pollution in these wide open spaces; it may have been cold but it was considered very healthy. Lead miners were keen to own a piece of land to farm it, as their working day was short, to supplement their food supplies and income. In Allenheads and Coalcleugh the average acreage of smallholdings was between one and ten. The rest of the family would have been involved in this farming too. Despite the advantages of home-grown food, what killed the workers at an early age were the slivers of ore from the mines that went into their lungs.

Smallholdings are a common feature of the lead mining moorlands, and we can still trace these, but many miners were so far from their work that they had to live in lodgings during the week, taking basic food with them. The Enclosure movements that were common in the eighteenth and nineteenth centuries resulted in the moorland being divided by hedges and walls and these can still be seen. Today industrial and other buildings have decayed and collapsed, leaving only limited examples of their existence, although some of their places of worship and schools survived longer. Some houses have been re-vitalised by people who are prepared to spend money on living in more remote areas of the county, and parts of the industry have been retained as tourist venues. Otherwise, the landscape can be bleak and sad when we discover the life that has been lost when lead was no longer a viable industry. The valleys have a different history, where farming was always the main occupation, with an emphasis on sheep and cattle.

The landscape may be 'outstanding' but it is not 'natural' for it has been exploited radically. It is heartening today in an overcrowded island that so much openness and

solitude exists, but it is also a sad that the life has gone out of it, for when the mines closed the people went away, many abroad, for there was no alternative work for them.

The sheer extent of the mining operation is seen here, where the valley sides have been gouged out in the search for minerals. A waggonway penetrated a mile into the hillside, to allow a horse to draw out wagons of ore. Spoil was dumped.

Further downstream towards Allendale the valley has more small farms and less mining.

The boundary between Northumberland and Cumbria at Nenthead is on a ridge, both sides of which look out over extensive open land that supports rough grass and heather, and is pitted with quarries.

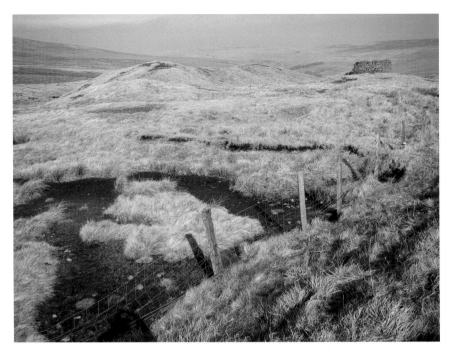

Towards Coalcleugh (the coal cliff) the land has been mined, with spoil heaps and marshy areas visible. One use of this moorland now is for grouse shooting.

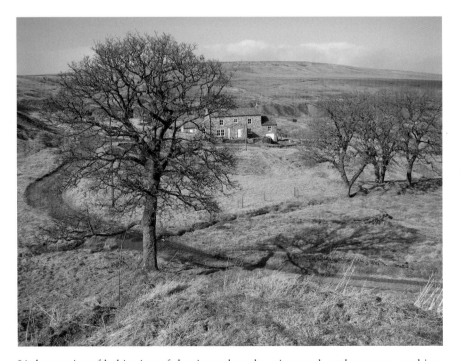

Little remains of habitation of the time when the mines and smelters were working, but this house has survived above the West Allen Valley as well as the mine buildings below at Carrshield.

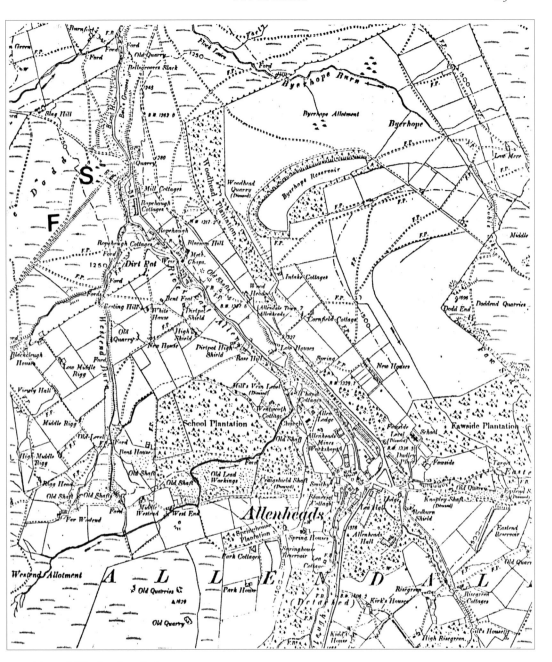

Map of Allenheads, 1898.

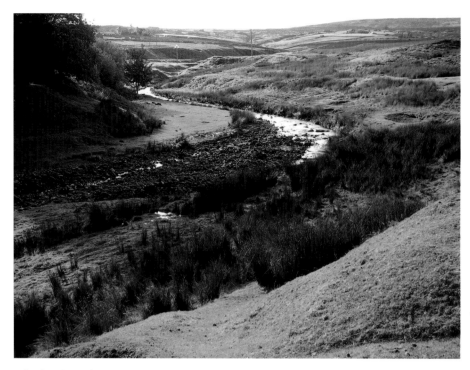

Allenheads, as the name suggests, is at the head of the East Allen Valley, seen here from the south towards the village.

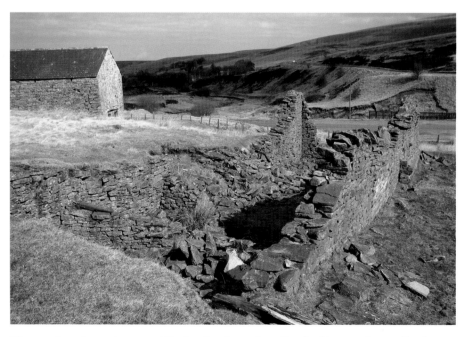

The remains of a smelter near Allenheads, above the valley, looking north-east. Further up the hill to the south-west, the view is over the smelting site and a small reservoir above it, marked as a sheepwash.

A track is an old carriageway that follows the line of the flue from the smelter up the hill to the south-west. The hills in the background, Allendale Common, rise from the east bank of the river.

In the valley, left, we see the beginning of Allenheads village. All the ground has been intensively mined, including the river bank, and in the foreground a faint ditch marks the course of the flue from the smelter towards Killhope, south-west. The walls were built to enclose 'waste' or 'moor' land during the late eighteenth and nineteenth centuries.

At Catton Moor and Stublick there are fine examples of intact flues and chimneys. At Langley and Stublick, pictured here, far north of Allenheads, near Haydon Bridge, the limestone was also exploited for lead. Here is a flue tunnel, partly exposed, leading to the chimney. Stublick chimney has been preserved as an example of how toxic fumes were led through tunnels far away from the smelter because of the danger that they posed for humans, animals and vegetation. We now return to Allendale.

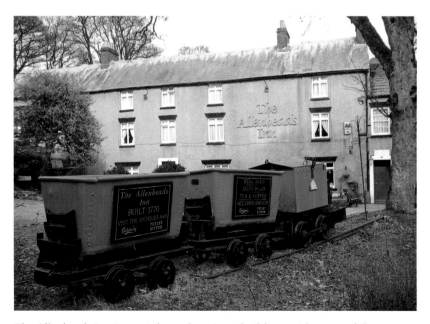

The Allenheads Inn is an eighteenth-century building, with some of the wagons on show that were used to transport ore and 'deads' from the mines. The amount was checked in 'bouses' in a large yard.

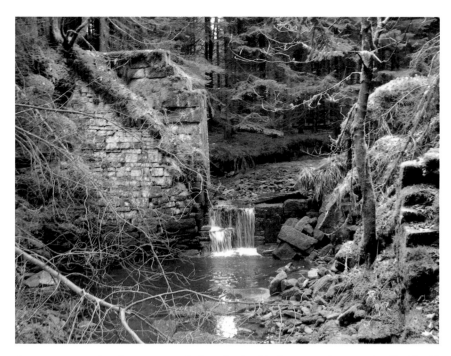

A constant supply of water was vital to the lead industry, and reservoirs like Dodd Reservoir, above the valley, were created. They are now a particular attraction for birds such as ducks and oyster catchers. At the Heritage Centre a dam has been preserved on a public trail. Some of the original buildings of the mining settlement have been preserved.

The valley in which houses were built has large spoil heaps, and a tree grows out of a stone shaft.

The centre of the industry was the washing floor, where the 'bouses' for the ore form an orderly line. There were offices here too. There is a scatter of houses over the moors at a considerable height above the valleys, where the main settlements and offices were. Here is an example of land enclosed by stone walls, favoured for smallholdings.

Limestone outcrops were used all over the county to 'sweeten' soil, for disinfectant and whitewash. The stone was quarried and then burnt in kilns; here we see the limestone quarry face above the filled-in section just off the minor road from Allenheads to Coalcleugh, with the kiln that used it.

5

Igneous Intrusions

Local intrusions of basalt have produced a distinctive variation, seen along the coast at places like Bamburgh, but also in many inland dykes that follow faults generally in a south-westerly direction. Among the most famous are sites along Hadrian's Wall, but others are notable as quarries for road metal. We have seen this at Cawfields, and there are two more examples in the illustrations.

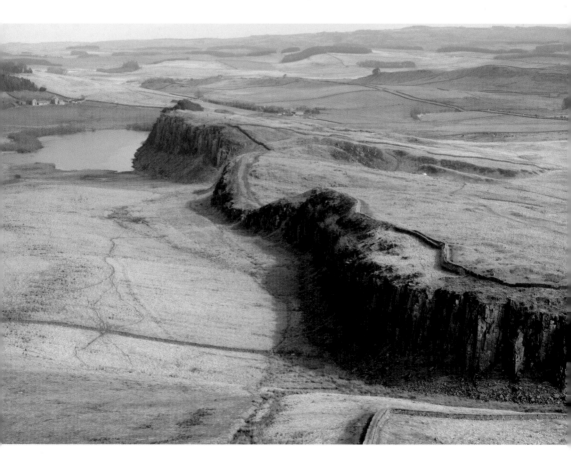

The Roman Wall central section famously makes use of the vertical whinstone crags in its cross-section of England, east to west. (Tony Iley, 'The Hexham Courant')

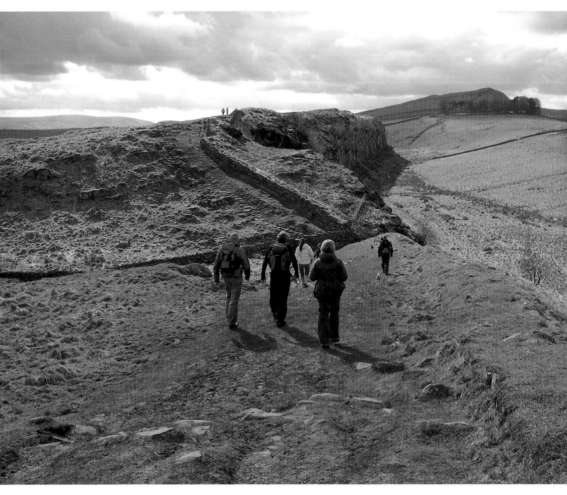

Hikers follow the Wall westward from Crag Lough to a Milecastle. It is a reminder that the best way to see the country is on foot – if you can manage it.

Bibliography

Beckensall, S., *Prehistoric Rock Art in Northumberland* (Tempus, 2001).

Beckensall, S., *Northumberland: the Power of Place* (Tempus, 2001).

Beckensall, S., *Prehistoric Northumberland* (Tempus, 2003 and 2006).

Beckensall, S., *Northumberland: Shadows of the Past* (Tempus, 2005).

Beckensall, S., *Place names and field names of Northumberland* (Tempus, 2006).

Beckensall, S., *Hexham: history and guide* (Tempus, 2007).

Beckensall, S., *Northumberland from the Air* (History Press, 2008).

Beckensall, S., *Prehistoric Rock Art in Britain* (Amberley, 2009).

Beckensall, S., *Northumberland's Hidden History* (Amberley, 2009).

Beckensall, S., *Empire Halts Here: viewing the heart of Hadrian's Wall* (Amberley, 2010).

Beckensall, S., *Coastal Castles of Northumberland* (Amberley, 2010).

Frodsham, P., *Archaeology in the Northumberland National Park* (CBA, 2004).

Frodsham, P. and O'Brien, C. (eds), *Yeavering: People, Power and Place* (Tempus, 2005).

Frodsham, P., *In the Valley of the Sacred Mountain* (Northern Heritage, 2006).

Robson, D. A., *A Guide to the Geology of the Cheviots* (TNHS of Northumbria, Newcastle, 1976).

Robson, D. A., *A Guide to the Geology of Northumberland and the Borders* (TNHS of Northumbria, Newcastle, 1966).

Scrutton, C. (ed), *Northumbrian Rocks and Landscapes* (Yorkshire Geological Society, Ellenbank Press, Cumbria, 1995).

Waddington, C. and Passmore, D., *Ancient Northumberland* (English Heritage, 2004).

Index

Coastal Castles of Northumberland

Stan Beckensall

Stan Beckensall traces the nature of Northumberland's coastal castles
and their roles in the lives of the people of the area.

978 1 4456 0196 0

192 pages, colour illustrations throughout

Available from all good bookshops or order direct
from our website www.amberleybooks.com

Northumberland's Hidden History
Stan Beckensall

An engaging insight into Northumberland's hidden heritage. Dr Stan Beckensall focuses upon places that are off the beaten track, not so well known, but all of enormous interest for their stunning locations and stories.

978 1 84868 368 6

160 pages, 145 b&w and 24 colour illustrations

Available from all good bookshops or order direct from our website www.amberleybooks.com